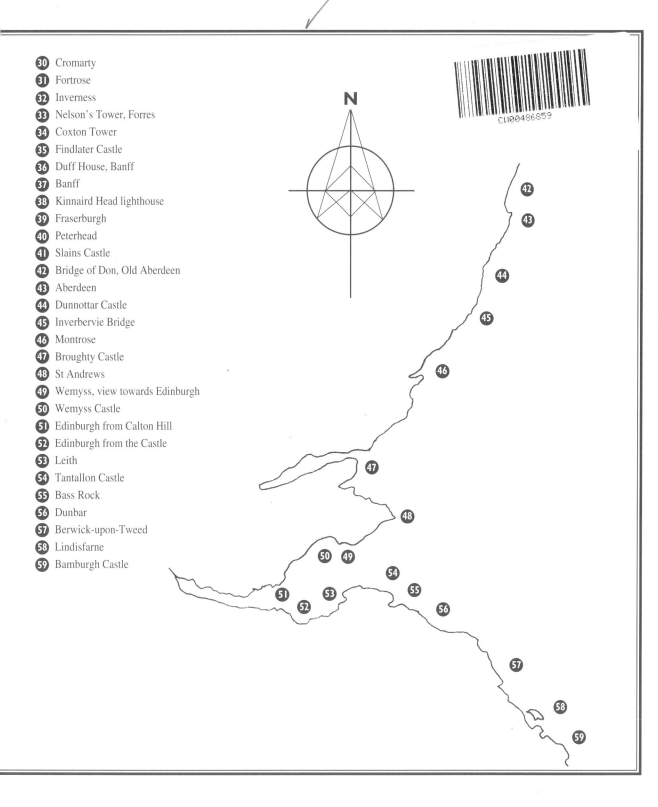

30 Cromarty
31 Fortrose
32 Inverness
33 Nelson's Tower, Forres
34 Coxton Tower
35 Findlater Castle
36 Duff House, Banff
37 Banff
38 Kinnaird Head lighthouse
39 Fraserburgh
40 Peterhead
41 Slains Castle
42 Bridge of Don, Old Aberdeen
43 Aberdeen
44 Dunnottar Castle
45 Inverbervie Bridge
46 Montrose
47 Broughty Castle
48 St Andrews
49 Wemyss, view towards Edinburgh
50 Wemyss Castle
51 Edinburgh from Calton Hill
52 Edinburgh from the Castle
53 Leith
54 Tantallon Castle
55 Bass Rock
56 Dunbar
57 Berwick-upon-Tweed
58 Lindisfarne
59 Bamburgh Castle

N

CU00486859

A VOYAGE
ROUND GREAT BRITAIN

Volume 4

Orkney to Southend-on-Sea

A VOYAGE ROUND GREAT BRITAIN

Volume 4
Orkney to Southend-on-Sea

by

David Addey

in the footsteps of William Daniell R.A.
(1769-1837)

Foreword by

Sir Stephen Tumin

SPELLMOUNT
Staplehurst

British Library Cataloguing in Publication Data:
A catalogue record for this book is available
from the British Library

Copyright © David Addey 2002
Foreword © Sir Stephen Tumin 2002

ISBN 1-86227-184-4

First published in the UK in 2002 by
Spellmount Limited
The Old Rectory
Staplehurst
Kent TN12 0AZ

Tel: 01580 893730
Fax: 01580 893731
E-mail: enquiries@spellmount.com
Website: www.spellmount.com

1 3 5 7 9 8 6 4 2

The right of David Addey to be identified
as the author of this work has been asserted by
him in accordance with the Copyright Designs
and Patents Act 1988

All rights reserved. No part of this publication may
be reproduced, stored in a retrieval system or
transmitted in any form or by any means,
electronic, mechanical, photocopying, recording or
otherwise, without prior permission in writing from
Spellmount Limited, Publishers.

Typeset in 11/12 Baskerville by
MATS, Southend-on-Sea, Essex

Printed in China

GENERAL NOTE

This is the fourth and final volume of my journey round Great Britain in the footsteps of William Daniell. The previous stages, from Sheerness to Land's End, Land's End to the Clyde and the Highlands and Islands of Scotland, were published in 1995, 1997 and 2000 respectively.

Daniell and his companion, Richard Ayton, began their exploration of the coast at Land's End in 1813, and travelled together until they reached Kirkcudbright in 1816, where they parted company. Daniell continued on his own through the Highlands and the Western Isles, Orkney, along the north and down the east coasts of Scotland and arrived in Dundee in 1818. He resumed his travels in August 1821 and completed his circumnavigation at Land's End in 1823. My Voyage started at Sheerness in 1988 and, travelling intermittently, I arrived in Orkney in 1997. In September 1999, before beginning the seventh stage of my Voyage, I flew to the Orkney island of North Ronaldsay, where I had been asked to paint a watercolour of the old lighthouse there – one that Daniell had missed on his visit to the islands. I completed the ninth and final stage of my Voyage when I arrived at Southend-on-Sea in May 2002.

Except for some minor adjustments, the extracts from Daniell's extensive narrative are as written by him. The spelling of certain words in use at the beginning of the 19th century has been maintained. The titles to Daniell's views are those as spelt in the margins beneath his aquatints which, in some cases, are different from those in his text.

ACKNOWLEDGEMENTS

The Voyage in the footsteps of William Daniell is now complete, and throughout the stages that are depicted in this final volume I have again received unstinting help from many people. I have been provided with most welcome accommodation, granted access to private properties, and willingly given assistance on facts and figures by friends and strangers, Tourist Board Officers, local historians and curators of museums and libraries. Their co-operation throughout, which has contributed to the enjoyment and success of the project, is gratefully appreciated.

My thanks to Jamie Wilson of Spellmount Publishers who has patiently and expertly brought my writings and paintings together for the fourth time, to Beth Macdougall of MGA, Spellmount's PR and marketing arm, for her enthusiastic promotion of the project, and to Peter Humphreys of Wells Graphics for his photographic skills.

I am greatly indebted to Martyn Gregory for his original suggestion that I should embark on this epic adventure and for his continued support throughout its duration. To Penelope Gregory, for her forbearance when I disturb the tranquillity of the gallery for my exhibitions and finally to all those who have purchased paintings and books thus greatly assisting the financial aspects of the Voyage and the publication of the four volumes.

FOREWORD

When you fly from London to Orkney, changing planes at Aberdeen, and landing at Kirkwall, you have made nearly half the William Daniell Voyage in a few hours. He spent nearly six years pottering around the coast and, finding the winds too strong at sea, travelled mainly by horse and gig.

A Voyage Round Great Britain in Daniell's production was an early guide book, prepared by a considerable artist. Since then the landscape on the coast of Britain has changed very little. There are, for example, a few more trees in Orkney now, and there have been some modest alterations around the coast in repainted houses. The big cities and towns are different, but not the rocky coast. Mr Addey has often painted from the precise spot where Daniell once stood to draw.

Although he does not set out the price of B&Bs, the current transport system, the theatres and the cinemas, Daniell, supported by Addey, remains a pretty sound guide to what you will find on our coast. The aquatint of the early 19th century provides an interesting comparison to the watercolour of the late 20th century, in particular where they relate, as they so often do, to towers, spires, castles and lighthouses. Mr Addey's pictures go back (as his patron Martyn Gregory once wrote of his work) to the 'depiction of the bones of a place without fuss or embroidery'. He notes where Daniell exaggerates or romanticises. Daniell had painted much in India and he had a fondness for high seas. I have an aquatint by him of a storm off the Cape of Good Hope where all aboard are about to be shipwrecked. However, Daniell returned to England and eventually became an Academician, apparently winning election over John Constable.

But my favourite edges of Great Britain, Cornwall and Orkney, cannot be more happily portrayed than by a combination of William Daniell, sometimes inaccurate but always picturesque, and David Addey, calm and careful. To choose a favourite Daniell is tricky: I like the Orcadian 'Old Man of Hoy'. With David Addey's work you must choose for yourself, as you move on paper through the splendid volumes from Land's End to Land's End by way of Orkney.

Sir Stephen Tumin
May 2002

INTRODUCTION

William Daniell has been my silent companion for over 14 years. As I followed in his footsteps I became acutely aware of his extreme professionalism. From an early age his artistic skills were soon recognised and it was his uncle, Thomas, who gave him tuition and encouragement. Together they went to India in 1784, travelled extensively for nine years and, on their return, settled in London at 37 Howland Street, Fitzroy Square. They then proceeded to produce the most remarkable series of aquatints of that country in their *magnus opus*, the *Oriental Scenery* – an enormous undertaking in six volumes with 144 coloured aquatints which were published between 1795 and 1808.

In 1801 William married Mary Westall, eldest sister of Richard Westall A.R.A., and subsequently they moved to 9 Cleveland Street, Fitzroy Square. They had four daughters, three of whom married but remained childless. Their eldest daughter, Rose (she was married twice, each time to a George Wood!), had an adventurous life, spending some years in America, and died in 1912 aged 100. Another daughter, Susan, exhibited as a miniaturist at the Royal Academy between 1826 and 1845, first under her own name and later as Mrs Gent. The other two daughters were Emma, who also married into the Wood family, and Mary Ann who remained single.

The Daniell's were associated with Chertsey through the White Swan (now The Olde Swan) where the lessee in the middle of the 18th century was Thomas's father, John Sheppard Daniell, who was succeeded by Thomas's elder brother, William, and his wife, Sarah. Their first son, Samuel, was born in 1775, and became a successful artist, but died in Ceylon at the early age of thirty-seven. William was born in 1769 and died in Camden Town on August 16th 1837. Thomas, his uncle, died at the age of 91 in 1840.

What are the claims of these three talented artists? They portrayed with clarity and honesty in oils, watercolours and aquatints, the architecture, the landscape and the fauna of India, Ceylon, China, and South Africa; and one, William, faithfully recorded the Britain of the early 19th century in a way that has never been equalled. Between them they perfected the art of the aquatint which they raised to the highest standard with many impressive publications. Their's was a true family achievement: Thomas and William with *Oriental Scenery*, Samuel with *African Scenery* and *Ceylon,* and William with *Windsor* and *A Voyage Round Great Britain.*

It was in 1813 that Daniell embarked on the epic Voyage Round Great Britain. He invited Richard Ayton to be his companion as he needed someone to write the text to his volumes, thus leaving him free to concentrate on the artistic aspects of the great tour. Ayton, born in 1786, was 17 years his junior and particularly interested in the social aspects of the period. Perhaps he spent too long in his research and slowed Daniell's progress for, although they eventually parted company near Kirkcudbright in 1816, there were earlier signs of disenchantment at Whitehaven. It had been intended that Ayton, who was a good Greek and Latin scholar, would go to

University, but, with his father and grand-father dying in quick succession, the family fortunes declined. He eventually worked in a solicitor's office in Manchester and then moved to London. Very soon he forsook the law and settled on the Sussex coast at Seaford, where he spent most of his time in bodily exercises, fishing or reading. He died in 1823, aged 37, just before Daniell reached Land's End.

Between 1814 and 1825 the *Voyage* was published in eight volumes with a total of 308 aquatints. The text for the first two parts from Land's End to Creetown, near Kirkcudbright, was by Ayton; thereafter it was by Daniell. Many of these volumes were broken up and it is rare to find a complete set in good condition. A recent realisation at auction was £19,000 in 1999. In 1972 the Tate Gallery acquired the original copper plates and, in 1978, a limited edition of the engravings was published, accompanied by the complete text with illustrations in two volumes.

It was Martyn Gregory, the London fine art dealer, who suggested that I might follow in Daniell's footsteps, and with my interest in buildings, ships and the sea, I needed little persuasion to embark on this great Voyage. Undoubtedly the physical aspect of it has been much easier for me than it was for Daniell. We can only be full of admiration for his per-severance and skill in all that he achieved at a time when travel was extremely tedious and accommodation difficult to find. It has to be remembered that not only was he travelling round the coast of Great Britain between 1813 and 1823, he was producing other engravings, publications and oil paintings for submission to the Royal Academy, where he exhibited more works than any other artist before or since. It was said that he often worked from six in the morning until midnight. He was elected an associate of the Academy in 1807 and a full Academician in 1822.

In 1828 Daniell set foot in Ireland probably with the idea of exploring its coast, and although he produced at least 26 drawings between September and October, nothing similar to the Voyage materialised. His final major journey took him to France in September 1833. Probably regarded as a holiday, he would not consider it a holiday unless he did some work, and in consequence he produced forty-three drawings of the Rhone valley.

There have been many times when I have envied Daniell and his 19th century subject matter, particularly where the locations have been intensively developed since his visit. There are certainly places that I would not have chosen, but it has been an interesting discipline to be faced with views that had no attraction for me.

It was disappointing to find that so much modern 'architecture' looked the same, and terrible, in many places - 'architecture' is not the appropriate word, as the true art of designing buildings was often sadly lacking. Daniell was fortunate to witness the climax of the Georgian period and the birth and development of the Regency. While some places have improved in the last 180 years others have lost their old-world charm with the growth of commercialism. Daniell was enthusiastic about the benefits of progress and also witnessed the birth of the Industrial Revolution; I wonder, though, if he could foresee the effect it would have on the scenes he depicted. It is interesting to note that in 1820 the population of England, Scotland and Wales was 14 million whereas in 1996 it was just over 57 million. During his visit to the Clyde in 1814 he embarked on and depicted an early boat propelled by steam; he saw and,

quite rightly, admired the works of his engineering contemporaries, Thomas Telford, John Smeaton, John Rennie, the Scottish 'lighthouse' Stevensons, and the English engineer, Robert Stephenson.

The drawings Daniell made for the *Voyage Round Great Britain* were small, the size, 165mm x 237mm, being dictated by the ultimate purpose for which they were made. Generally they are little more than lightly tinted sketches, and some bear no colour at all. Back in his studio Daniell would then produce the aquatints from his sketches. My method of working is similar, although the completed drawing, with simple colour notes, forms the basis of the finished watercolour.

With years of experience Daniell was proficient in finding the best viewpoint of his subject, and in several of these I am sure that I was sitting in exactly the same position. Very often the best view was not the most obvious, and in my travels I found several viewpoints which, for one reason or another, I was not able to depict, or some that had been totally obliterated. Throughout, it has been a great joy and a most rewarding adventure to follow in his footsteps. Perhaps, one day in the future, someone else will tread the same path on another Voyage Round Great Britain.

BIBLIOGRAPHY

Addey, David	*A Voyage Round Great Britain, Sheerness to Land's End.* Spellmount Ltd., Staplehurst, 1995 *A Voyage Round Great Britain, Land's End to the Clyde.* Spellmount Ltd., Staplehurst, 1997 *A Voyage Round Great Britain, The Highlands and Islands of Scotland.* Spellmount Ltd., Staplehurst, 2000
Allardyce, Keith and Evelyn M. Hood	*At Scotland's Edge.* HarperCollins, 1996
Allardyce, Keith	*Scotland's Edge Revisited.* HarperCollins, 1998
Bryson, Bill	*Notes from a Small Island.* Black Swan, 1996
Daniell, William and Richard Ayton	*A Voyage Round Great Britain.* The 1977 edition with notes, published by the Tate Gallery Publications Dept.
Drive Publications Ltd.	*Illustrated Guide to Britain's Coast.* The Reader's Digest Association Ltd., 1984
Hunt, Shally	*The Sea on Our Left.* Summersdale, 1997
James Lander and Geoff Chapman	*Historic Chertsey.* A Guided Walk, 1997
Mooney, The Reverend Harald	*St Magnus Cathedral, Orkney.* Society of the Friends of St Magnus Cathedral and Jarrold Publishing, 1995
Sale, Evans and McLean	*Walking Britain's Coast – an aerial guide.* Unwin Hyman Ltd., 1989
Somerville, Christopher	*Coastal Walks in England and Wales.* Grafton Books, 1988
Sutton, Thomas	*The Daniells, Artists and Travellers.* Theodore Brun, 1954
Tooley, R.V.	*English Books with Coloured Plates.* B.T.Batsford Ltd., 1987
Weaver, Leonard	*Harwich, Gateway to the Continent.* Terence Dalton Ltd., 1990

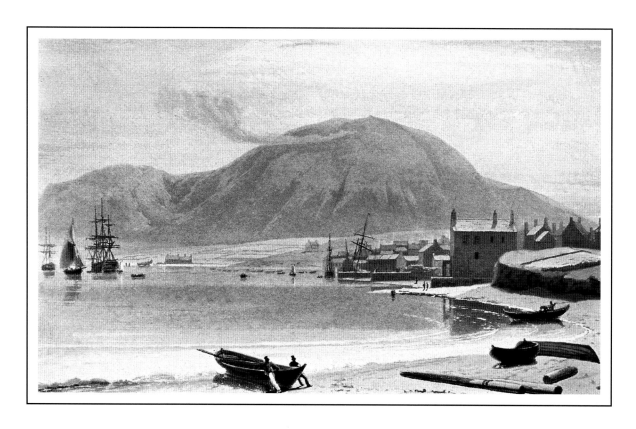

1 STROMNESS, ORKNEY

Stromness is a small sea-port situated at the north-east corner of Pomona, or the mainland of Orkney, in latitude 58 degrees 58 north and 3 degrees 12 west of Greenwich. The number of its inhabitants is now little short of 2000 and many substantial, though not many comfortable houses have been built within the last twenty years. This mass of habitations, reared almost at random, ranges along the side of the harbour, forming a lane rarely exceeding twelve feet in width, and, sometimes so narrow as four or five feet: it is clumsily paved with flag-stones of unequal sizes: its direction is serpentine, or rather zigzag.

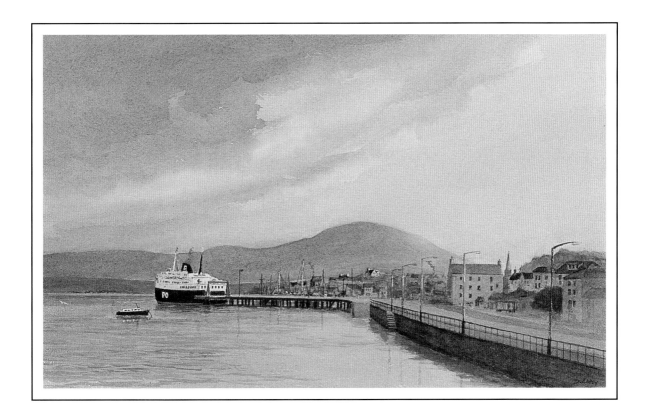

1 STROMNESS, ORKNEY

I arrived at Stromness in the early afternoon of 22nd September 1997, and immediately looked for accommodation. My early enquiries revealed nothing suitable, and I was beginning to despair until I knocked on the door of an address that had been given to me by some friends. Imagine my surprise and relief when I was warmly greeted and told that I had been expected.

The large building in both views was built in the early 19th century by Lt James Robertson RN, who commanded HMS *Beresford* at the battle of Plattsburg, New York State, in 1812. Called 'Speedings' it was modernised in recent years and converted into council flats, most of which are now privately owned. The P&O pier, which also dates from the 19th century, has been enlarged periodically with the new terminal building being built in 1999. The population of Stromness is still very much the same as at the time of Daniell's visit.

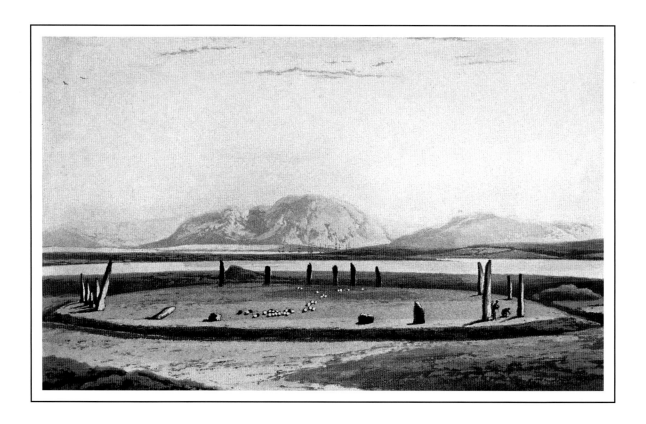

2 STONES OF STENNIS

Though by no means comparable with Stonehenge, these stones are undoubtedly very singular and interesting monuments of antiquity. They consist of two clusters, one of which, though many of the stones comprising it are thrown down, is a complete circle, fifty fathoms in diameter. The space between each stone, of which there are sixteen standing, is about five yards, the general thickness of them from sixteen to eighteen inches, and the breadth about three feet six inches.

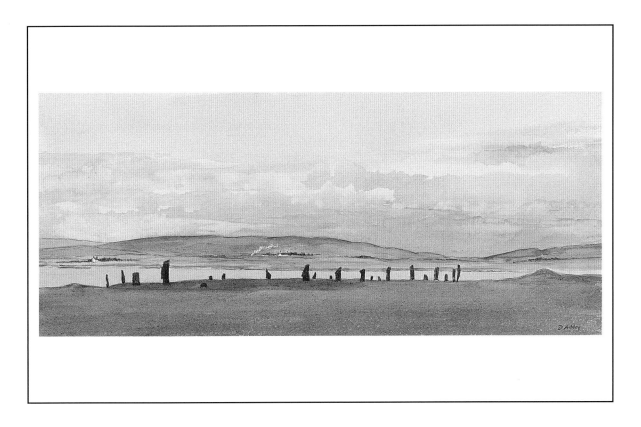

2 THE RING OF BROGAR

In the early 19th century it seems that the Ring of Brogar and the Stones of Stennis were bracketed under the same name. The stones depicted in these views are now called the Ring of Brogar or Brodgar while the Stones of Stenness, of which there are only three still standing, lie to the east and nearer the main road. Daniell shows 19 stones whereas there are 27 still standing, although six are little more than stumps. One was struck and felled by lightning in the 1980s, when there was considerable debate as to whether or not it should be re-erected but, quite rightly, it was left as nature intended. My view of the stones is looking northwards; Daniell's is looking south, but he would have had to be in an elevated position to achieve this.

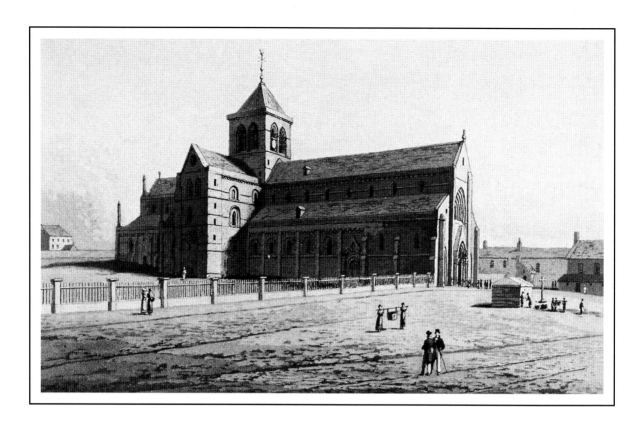

3 N-W. VIEW OF THE CATHEDRAL, KIRKWALL

The cathedral was founded in the earlier half of the twelfth century by Ronald, Count of Orkney, in honour of his uncle St Magnus, to whom it was dedicated. The following are the dimensions of the edifice: from east to west 236 feet in length, by 56 feet in breadth: transept 60 feet in length, by 33 feet in breadth; height of the main roof 71 feet, and from the level of the floor about 140 feet. The vaulted roof is supported on each side by fourteen pillars and the tower by four others of uncommon strength and beauty. The lofty spire, which formerly crowned the tower, was struck down by lightning, and its place is ill supplied by the present mean and stinted coping.

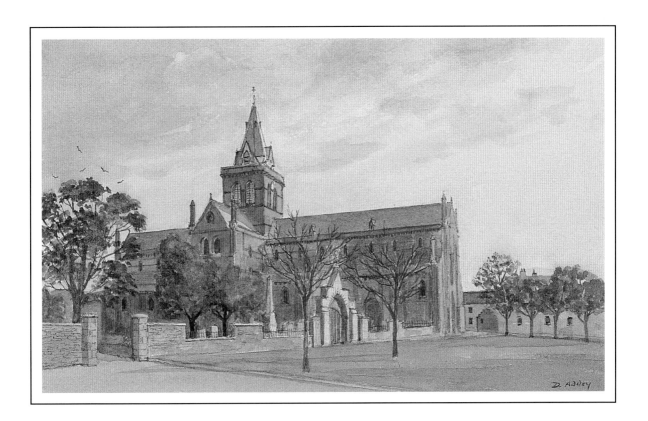

3 N-W. VIEW OF THE CATHEDRAL, KIRKWALL

This is the principal view of the cathedral and, apart from the spire and the trees, there has been little change. The stone pyramid on the cathedral's tower in Daniell's view was built in the late 17th century after lightning had destroyed an older spire. The present spire, cased in copper, was erected during a period of extensive refurbishment between 1913 and 1930.

The railings depicted by Daniell were replaced by a stone wall in the second half of the 19th century, with the War Memorial being added to it in the 1920s. Daniell has also shown a small, wooden hut on the right-hand side, which housed a well. Eventually, this was closed because the water, coming from the grave-yard, was not safe to drink.

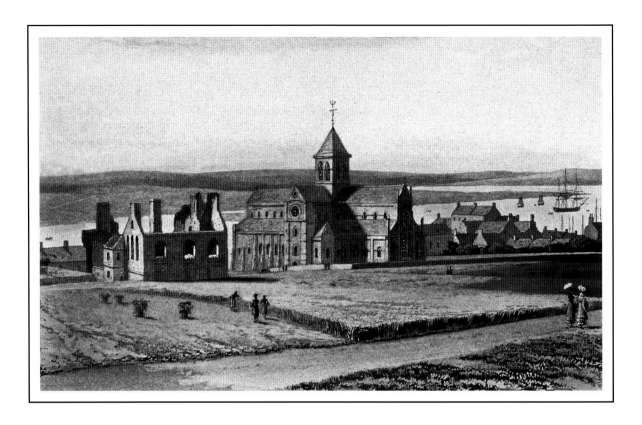

4 S-E. VIEW OF THE CATHEDRAL AND PALACE, KIRKWALL

The east window, which excels all the rest in size and symmetry, is 12 feet in breadth, and 36 feet in height, including a circular or rose window of 12 feet in diameter, by which it is crowned: in the south transept there is another rose window of the same dimensions, and in the west end of the nave there is a third window modelled after that which faces it, but much inferior in magnitude and proportion. The whole structure is in better preservation than many of the ancient ecclesiastical buildings in Scotland; and it owes this advantage, partly to the disposition of the people, but principally to the remoteness of its situation, through which it escaped the fiery zeal of the reformers.

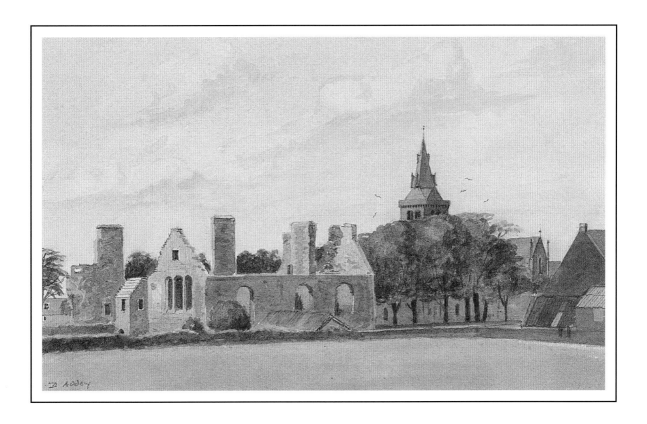

4 S-E. VIEW OF THE CATHEDRAL AND PALACE, KIRKWALL

St Magnus cathedral, built in a beautiful red stone quarried near Kirkwall and used, in places, with a yellow sandstone, is considered to be one of the best medieval examples in Britain of such use of two colours. However, a few years ago it became apparent that extensive repairs were necessary, and an appeal was set up with a twenty-five year programme of restoration at an estimated cost of £350,000 for the first five-year phase. Organised by the Friends of St Magnus, the appeal has raised nearly £1,000,000 over the last fifteen years. My viewpoint is slightly nearer to the subject than Daniell's, where there are now a school and a housing estate.

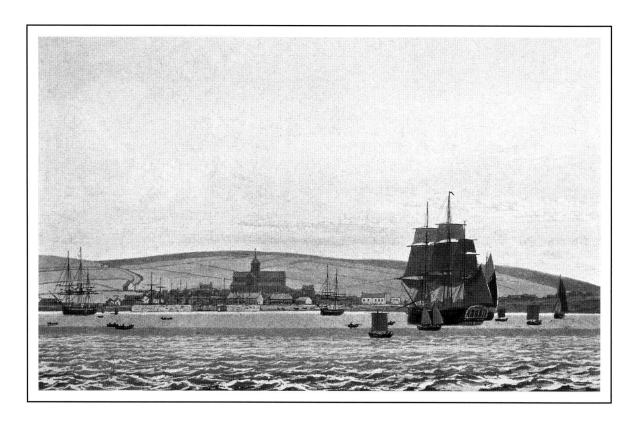

5 KIRKWALL, ORKNEY, FROM THE BAY

The town extends north and south in a curved line along the skirts of a small *oyse*, or inlet from the bay, and consists of a single street, about a mile in length, exceedingly narrow, ill paved, and dirty. The middle of the town indeed expands into an irregular oblong, which is considerably wider than what may be called the lanes at either end. The houses are huddled together very inelegantly, and, it should seem, very incommodiously for the inhabitants; but the varieties of light and shade produced by the irregular masses of building, aided by the venerable cathedral, and some ruins in the vicinity, afford no ordinary or contemptible subject for the pencil.

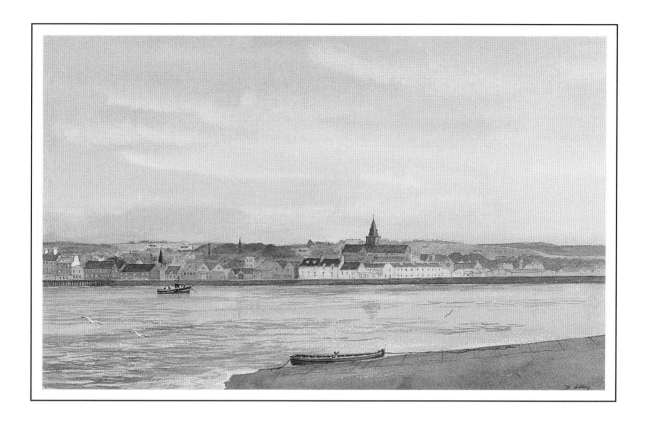

5 KIRKWALL, ORKNEY, FROM THE BAY

The cathedral is not nearly as prominent today, and there has been considerable development along the waterfront towards the harbour on the left. To do this view it was necessary to park on a small slipway and, after some time, I became aware of a car near by in which a man and a woman were having a furious argument. I had visions of being called as a witness to some dreadful murder but the car eventually sped off at great speed and I was left in peace – and to ponder on the outcome.

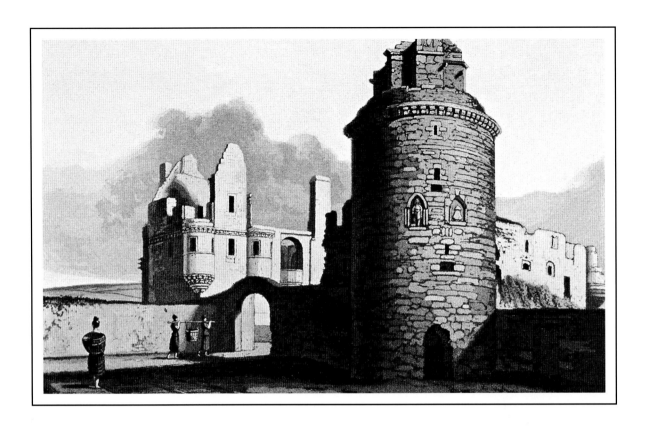

6 TOWER OF THE BISHOP'S PALACE, KIRKWALL

This palace is now wholly dilapidated, except the round tower, which was built at the north end of it by Bishop Reid, who also made considerable additions to the church. The view here given shows a small free-stone statue of the prelate, which has been permitted to stand, and has sustained little injury from the barbarians who pulled down and stole the materials comprising other parts of the bishop's manse, the interior of which is now occupied as a cow-house, and a repository for dung. It has since been resolved to abate this nuisance, and the barons of the exchequer have given directions to the sheriff of the county to protect the ruins.

6 TOWER OF THE BISHOP'S PALACE, KIRKWALL

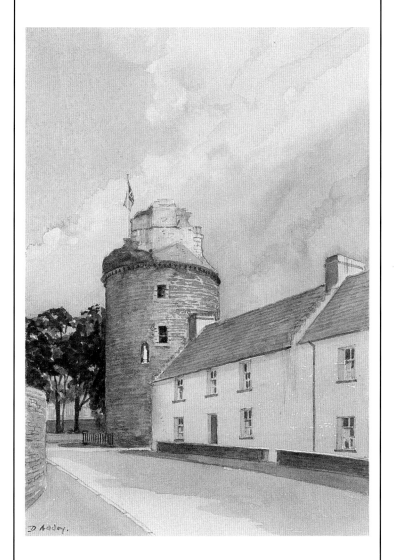

The tower has hardly changed, but the arch, depicted in Daniell's view, was moved round the corner to the Watergate in 1877 when the road was widened. The Earl's Palace, in the background, is now almost totally concealed by trees.

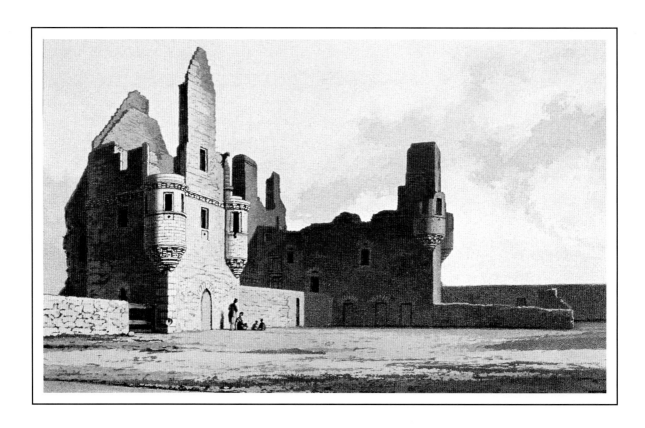

7 REMAINS OF THE EARL'S PALACE, KIRKWALL

The earl's castle, or old palace, is supposed to have been the ordinary residence of the royal governors, chamberlains, or farmers of the Orkneys, subsequently to the annexation of them to the dominions of the Scottish crown. It was erected in the fourteenth century by Henry Sinclair, the first of that name who was Earl of Orkney.

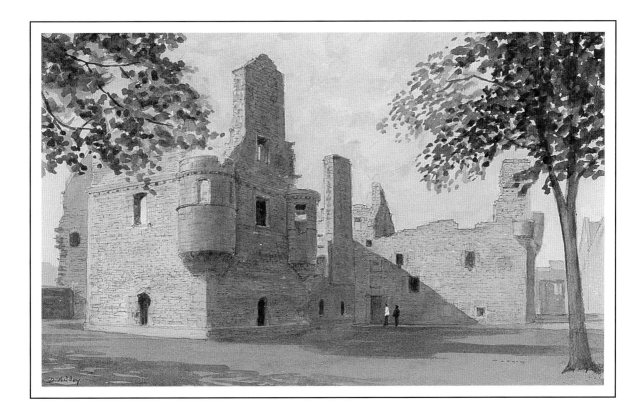

7 REMAINS OF THE EARL'S PALACE, KIRKWALL

The remains of the palace are much the same as at the time of Daniell's visit except that they are now largely obscured by trees and it was with some difficulty that I managed to compose this painting. Trees can be quite a hindrance at times, and on one occasion I was commissioned to paint a view of a house where a tree was in a particularly awkward position. I mentioned this to the owner as being a slight but not insurmountable problem but, to my astonishment, when I returned the next day the tree had disappeared.

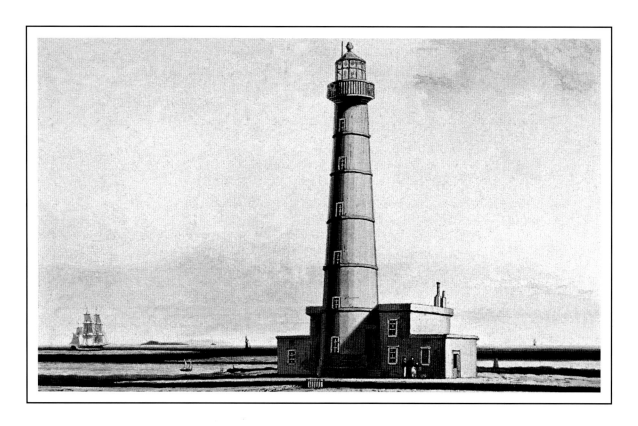

8 LIGHT HOUSE ON THE START, ISLE OF SANDY, ORKNEY

An excursion was made to this lighthouse situated on the Start, the extreme point of the island. It was erected not many years ago by order of the commissioners of the northern lights, and has since been the salvation of many vessels navigating these seas which, during the winter, are tremendous: indeed, it is calculated that on this low island there are more wrecks than in any other of the Orkneys. The spray often beats over this lighthouse.

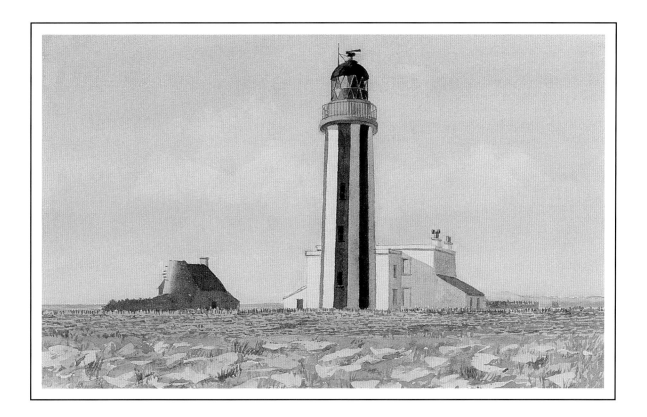

8 LIGHTHOUSE AT START POINT, ISLE OF SANDAY, ORKNEY

Start Point is an islet separated from the island of Sanday by a narrow causeway. My enquiries had revealed that I would have only about an hour to visit the lighthouse and do the necessary drawing before being marooned by the rising tide. The crossing by ferry from Kirkwall left me very little time to reach my destination but, eventually, after clambering over seaweed-covered rocks and splashing through puddles, I reached dry land and set off at speed to the outermost point of the islet. Total calm descended as I sat in glorious sunshine, my back to the North Sea with only the cries of seals and seagulls amidst the breaking surf. This was Daniell's 154th subject since he had left Land's End – exactly half his total output.

Designed by Thomas Smith and Robert Stevenson, the lighthouse was built in 1806 and automated in 1962.

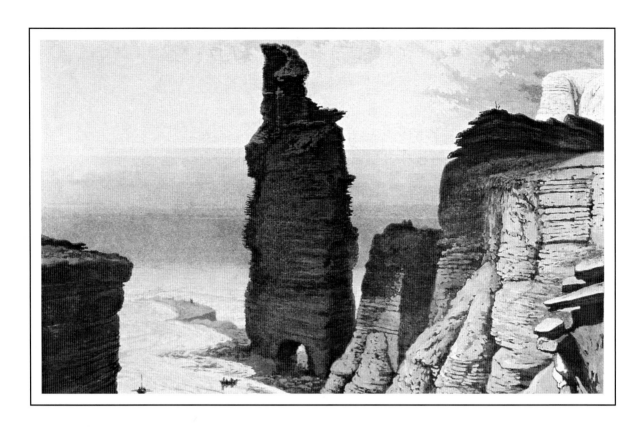

9 THE OLD MAN OF HOY

Among the remarkable features of the neighbouring coast is the Old Man of Hoy, also called the Stower, a detached pillar of rock, rising to the height of about 500 feet. The resemblance in which its appellation originates is altogether fanciful, and it might be more fitly compared to a ruined tower.

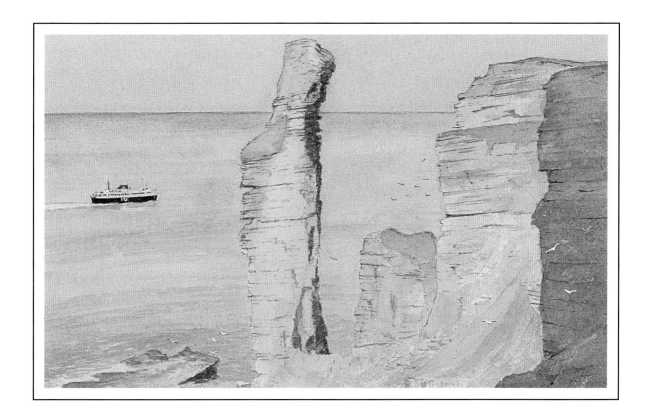

9 THE OLD MAN OF HOY

It is a walk of three miles from the small hamlet of Rackwick to this viewpoint, and I was blessed with continuous sunshine and total tranquillity throughout the day. The 450-ft (137m) Old Man, now half the width depicted by Daniell, presents a tempting object to climb, and this was first achieved on 18th July 1966 by Tom Patey, Chris Bonington and Rusty Baillie – rather them than me; I was quite content to sit comfortably near by and paint it. The second 'leg' of the Old Man collapsed over 150 years ago.

On my way back to the ferry I offered a lift to a gentleman hiker who, at first, was rather hesitant, probably preferring healthy fresh air to being cooped up in a small car. In a short space of time we discovered that not only were we both retired architects, but we also had a common interest in William Daniell.

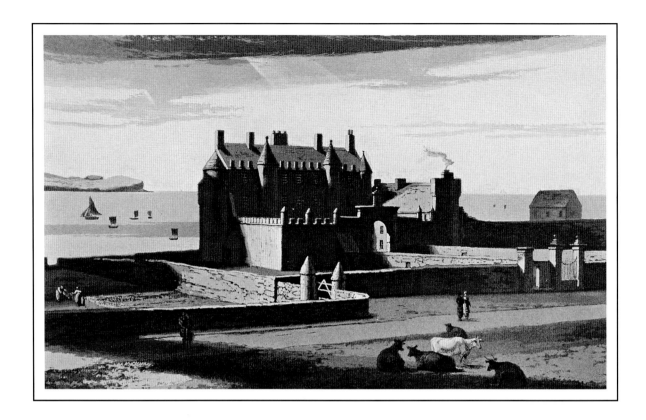

10 CASTLE SINCLAIR, THURSO

This edifice, which is also called Thurso East, or Thurso Castle, was once the residence of the Earls of Caithness. It stands pleasantly on the eastern side of the river, nearly opposite to the town. As a marine villa it forms an agreeable abode during the months of summer, in the height of which season scarcely any darkness prevails, there being a very strong twilight for the few hours during which the sun's disk is below the horizon. The air in this vicinity is considered peculiarly pure and salubrious.

10 THURSO CASTLE

The castle was built in 1664 by George, Earl of Caithness, substantially rebuilt by Sir Tallemache Sinclair in 1871, and then partially demolished by Sir Archibald Sinclair, First Viscount Thurso, in 1952. As it stands now, the turreted structure rather resembles a stage set, and turns it back on the sea against the prevailing winds. The present-day accommodation is at the right-hand end from where there is a fine view across Thurso Bay.

As on so many occasions I was made very welcome, and spent a peaceful two hours either working on my drawing or talking to the gardener, who was a fount of information.

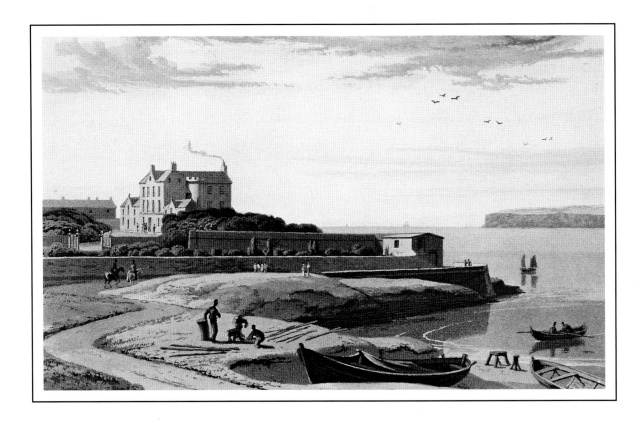

11 CASTLE HILL, NEAR THURSO

Castle Hill, the residence of James Traill Esq, commands an extensive prospect of the Pentland Frith, with the bold promontory of Dunnet Head to the right, terminating in a precipice four hundred feet perpendicular. The mansion is of modern date, and possesses all the conveniences and comforts befitting the residence of a gentleman. Under its hospitable roof, and in the elegant society of its domestic circle, an agreeable interval of repose was passed.

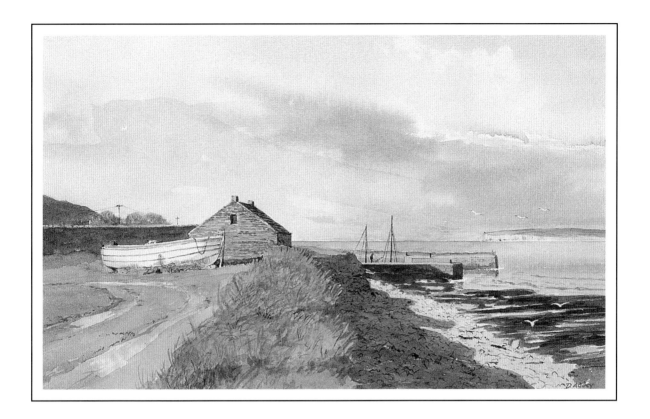

11 CASTLEHILL, NEAR THURSO

There are only a few signs here of a once thriving flagstone industry where the first cargo left Castlehill harbour in April 1825. The geological structure of the land is such that the pavings could be cut and dressed with relative ease. These were transported to ports down the east coast of Scotland and England, and to many parts of the world as far away as Australia and South America. The advent of cheaper concrete paving slabs put an end to this industry, which closed in the 1920s. The house was destroyed by fire in 1967, and only the surrounding wall and the harbour, built by James Bremner in 1825, remain.

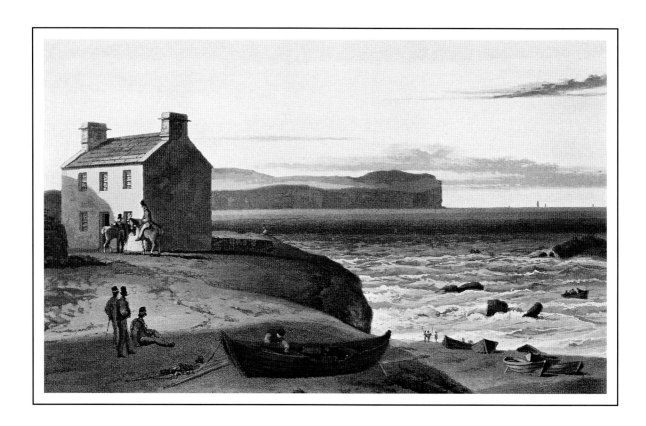

12 THE FERRY AT SCARSKERRY

An excursion was made on the 7th August 1818 from Castle Hill in company with Mr George Traill and Lt Moodie to Scarskerry. This is the usual place of embarkation for passengers to the Orkneys but the sea was at present too rough, the wind was too fresh and the boatmen were too timid to venture across the frith and after continuing to Mey Castle, the party returned the same evening to the residence of Mr Traill. On the following day, the weather having moderated, the passage was effected, in company with Mr Moodie, to Mailsetter, the house of his father.

Having landed at Brims near Mailsetter, the boat was discharged, the remuneration paid for it being fifteen shillings.

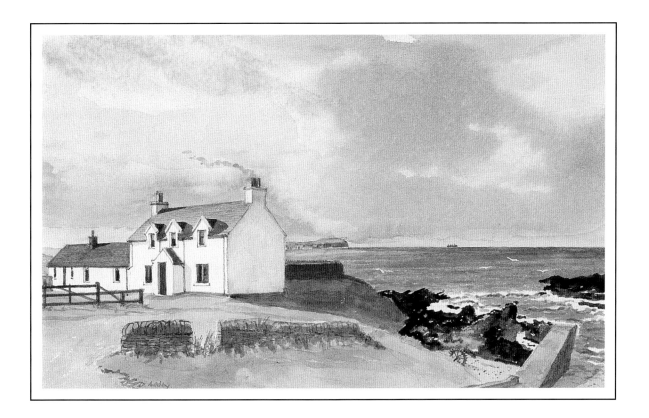

12 SCARFSKERRY

This scene has hardly changed since Daniell's visit, although the house has been modernised with a porch, dormer windows and a new roof. This was a strange choice of subject as it lacks any real content, and is a great contrast to almost all the other views that he had done hitherto on his Voyage. Perhaps, like any true artist, while waiting for the crossing to be made to Orkney, he felt the urge to do a drawing, and so took out his sketchbook. Daniell's reference to James and George Traill was of particular interest to me as I am acquainted with several of their direct descendants.

My visit here formed part of the 6th stage of my Voyage, which was completed on 27th September 1997.

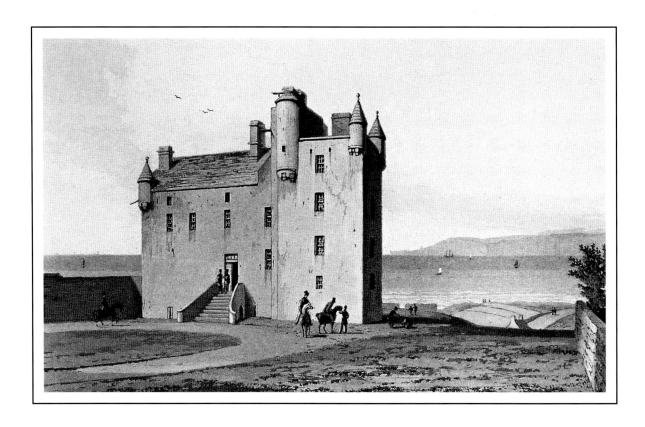

13 MEY CASTLE

Before proceeding to the Orkneys a halt was made at Mey Castle, also called Barrowgill, belonging to the Earl of Caithness. The shore, as may be seen in this view, is low and sandy; the distant land is part of the isle of Hoy, and the small point discernible in the lower part of the headland is the top of that well known sea-mark the Old Man. The extreme point is called Rora Head; and the intervening water is the Pentland Frith.

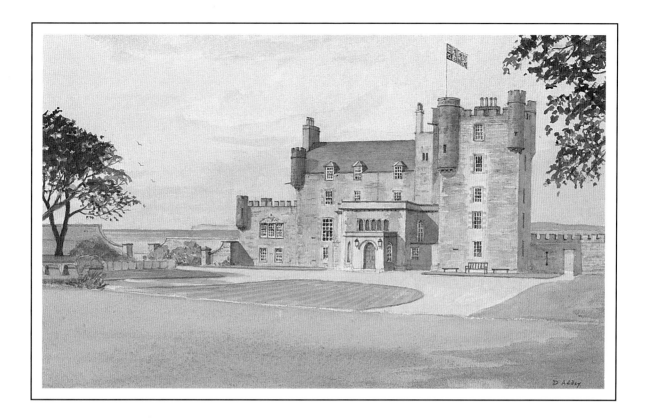

13 THE CASTLE OF MEY

The seventh stage of my Voyage began on 9th September 1999 with a visit to the Orkney island of North Ronaldsay to paint a watercolour of the old lighthouse there – one that Daniell had missed. The weather was at its most capricious with torrential rain accompanied by gale force winds that seriously affected the flights to and from Kirkwall, and my eventual return to the mainland where I had arranged to be at the Castle of Mey at 10 a.m. the next day. Fortunately, the storm abated for a while and I was able to continue my planned itinerary, arriving at the appointed hour.

Since 1952 the castle has been in the ownership of Queen Elizabeth, The Queen Mother, who restored it from a near-ruinous condition. Although Her Majesty was not in residence at the time of my visit, I was asked subsequently to incorporate her personal standard on my painting.

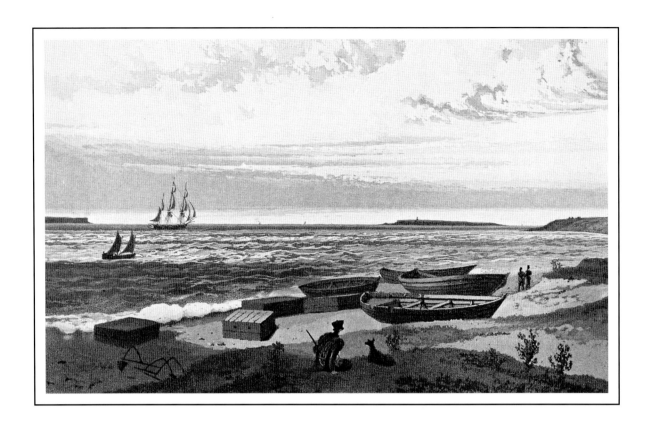

14 JOHN O'GROATS

This view includes in the foreground the site of the house erected here by that renowned ferryman John or Jan Grote. The chests in the foreground are lobster-traps, and the boats near them are in the customary position when drawn up for future use. Near this spot is the ferry, over which the packet is conveyed to Kirkwall.

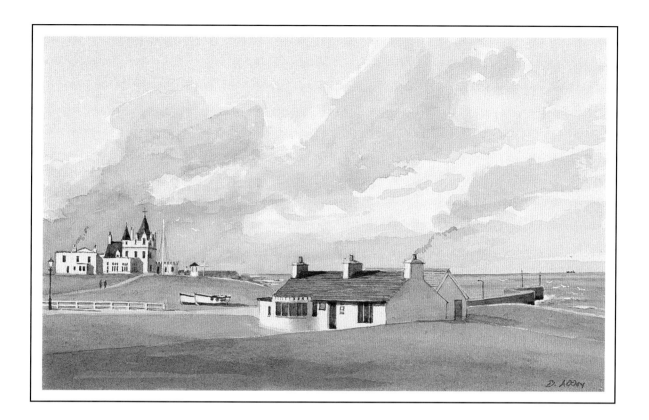

14 JOHN O'GROATS

The Daniell view is from the opposite direction and shows little of interest. I decided to look westwards and include the salient features of this almost northerly point of mainland Britain. In fact, Dunnet Head, about 12 miles to the west, extends nearly two miles nearer to the Arctic Circle. My view includes the John o'Groats Hotel, built in the 1870s, the pier and the signpost, which will tell you how far you are from anywhere. It was exactly nine years earlier – 11th September 1990 – that I had been at the other end of the mainland, 874 miles away by road.

John de Groot, the 16th century Dutch settler, who, harassed by strife among his eight sons, built for them an octagonal house on the site depicted by Daniell. The house had eight windows, eight doors and an eight-sided table, so that as they entered and sat down to eat, all or none of them took precedence.

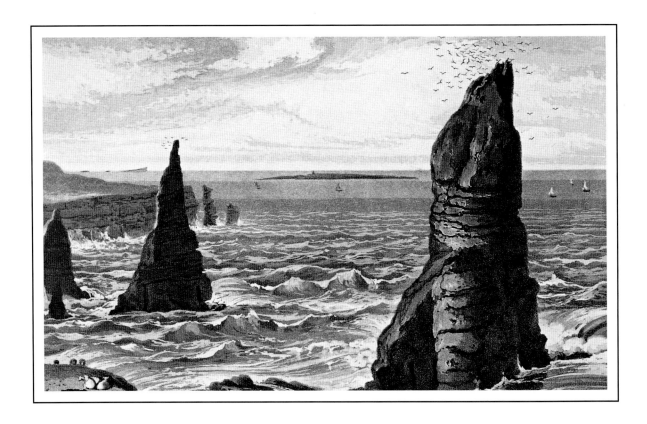

15 DUNCANSBY STACKS

These stacks afford some singular scenery of a rocky character. It is believed that in winter the sea breaks over them. At the time of this visit the weather was very mild, and the water exceedingly smooth.

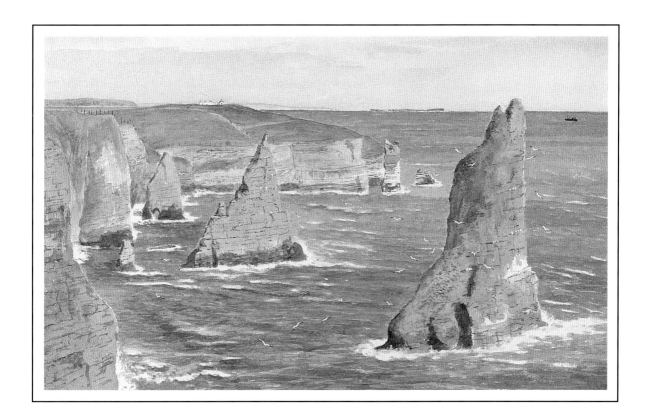

15 DUNCANSBY STACKS

It is worth taking the long walk to find Daniell's viewpoint, although it is preferable to be prepared for unrelenting rain, which I was not. I had to make a hasty retreat, and gradually became a miserable, sodden mess before eventually reaching the shelter of my car. However, the weather improved by the next day, and I was able to return to complete my task. Rather surprisingly, Daniell has taken a lower viewpoint than I would have expected, particularly as the cliffs are much higher than he has depicted. It is certainly not the place to be wandering around in the gloom, as one false step could soon send you crashing to the rocks below.

In the spring of 1940 the lighthouse on Duncansby Head was the first of the northern lights to be hit by German airborne machine-gun fire.

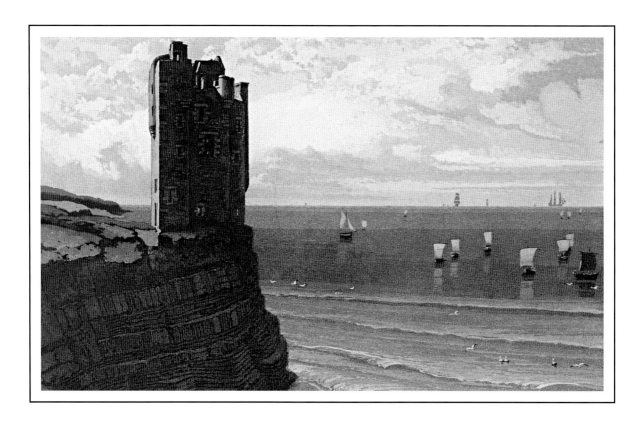

16 KEISS CASTLE

This castle was built about 400 years ago by one of the Earls of Caithness and stands on a red freestone rock, exhibiting a curious alternation of horizontal and perpendicular strata. The groups of boats introduced are employed in the herring fishery.

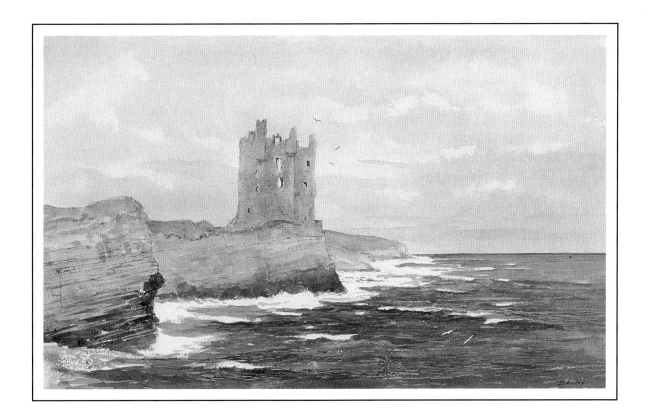

16 KEISS CASTLE

On my journey south from John o'Groats, these were the first castle ruins that I encountered, and not much has happened to them since Daniell's visit in 1818. Perched on its low cliff, the castle presents an imposing sight. A newer, three-storey Keiss Castle, built in 1755, lies a little farther inland. This was altered and extended in 1860 in the baronial style under the direction of the Edinburgh architect, David Bryce.

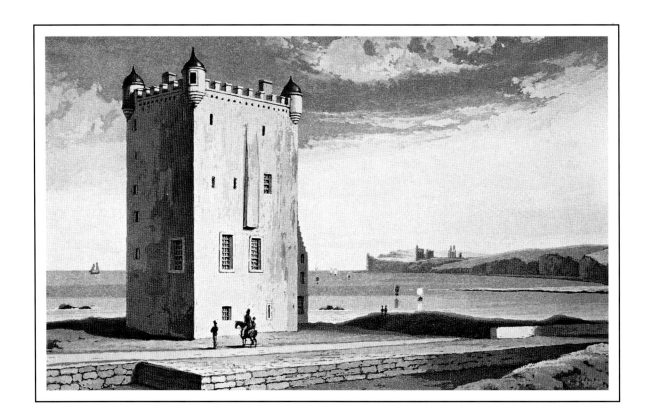

17 ACKERGILL TOWER

This tower will strike the reader who is acquainted with the Waverley novels as an interesting specimen of some of the feudal holds described in those enchanting tales. The very aspect of it, when contrasted with that of castles Sinclair and Girnigo in the distance, might suggest a hint for another of that series, which, like Banquo's line of kings, seems as if it 'ne'er end till the crack o' doom'. Mrs Radcliffe's neglected romance, called the Castles of Athlyn and Dunbayne, might have been imagined, if not written, on such a castellated shore as this of Caithness.

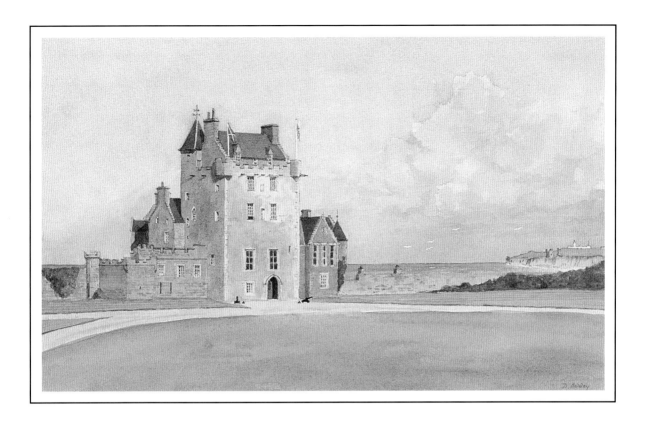

17 ACKERGILL TOWER

It often happens on this project that I have no idea what I am going to find when searching for a Daniell view. Having been told by a local inhabitant that access to this tower was difficult, I drove rather apprehensively down a long drive. But there was nothing to fear, and I was made most welcome. Built in 1476 by the Keiths, the castle was restored in 1987, and is now an exclusive location for high level business meetings, weddings and house parties. Some of the outbuildings have been converted into a small opera house, where musical events are held from time to time throughout the year.

Mrs Radcliffe, referred to by Daniell, travelled extensively, and her journals show how keen an eye she had for ruins and natural scenery. *The Castles of Athlin and Dunbayne* was published in 1789 when she was twenty-five years old. She died in 1823.

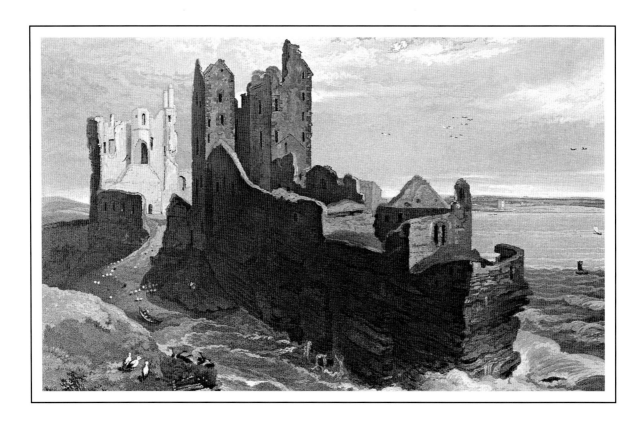

18 CASTLES SINCLAIR AND GIRNIGO

These castles are built on a jutting rock, which looks like masonry. It is scarcely necessary to repeat that all these strongholds were erected during the frequent troubles of Scotland in the feudal times. The situation of these ruins is very wild and striking. The workmanship of both is extremely rude; that of Castle Sinclair is manifestly the more modern.

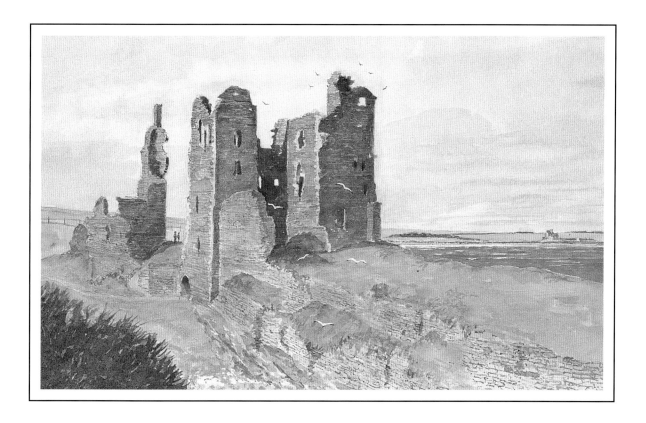

18 CASTLES SINCLAIR AND GIRNIGOE

Castle Girnigoe, on the right, was built in the 15th century while Castle Sinclair was built two centuries later. Both were seats of the Sinclairs, Earls of Caithness. Less of the ruins remain today and they are certainly not the place to explore with excitable children; there are unprotected openings that drop straight down to the boiling sea below. The name Girnigoe probably derives from 'geo' meaning a narrow cleft in the rock face and 'girn' being the sound that a sick child might make. Presumably the noise of the sea breaking into this particular geo reminded people of that sound, or perhaps it was the cries of the son of a tyrant in former days, who was kept in a dungeon, fed on salted beef and denied fresh water.

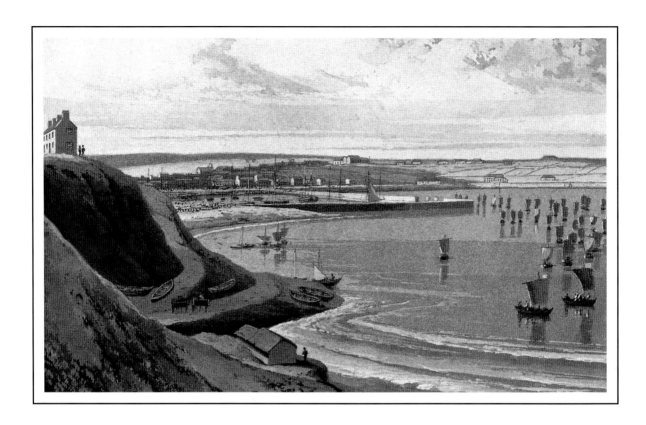

19 WICK

Wick is a small borough, seated on a river accessible to the tide. Of late, it has much increased in size from the prosperity of its herring fishery, and at the period of this visit those of its inhabitants employed in the fishery were very busy. The number of boats employed is little short of six hundred. The fish are sent chiefly to Ireland and the Baltic, and considerable exports are made to the West Indies. A crew of five men will, on a good night, earn two guineas each.

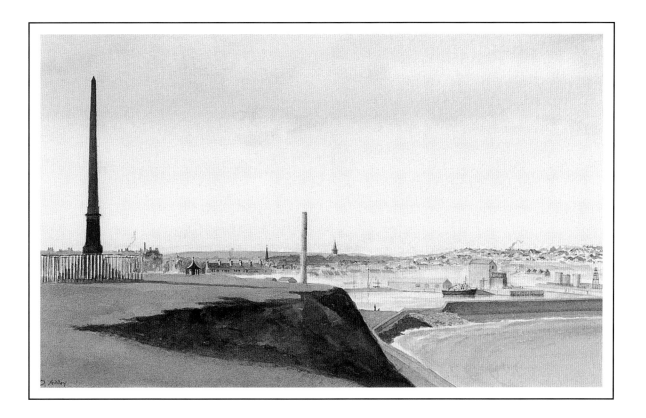

19 WICK

At first sight this view was extremely depressing as low cloud and rain obscured nearly everything. It was not an easy subject, but a clearing mist the next morning helped to hide some unfortunate buildings. A major overhaul of the piers took place after a huge storm and loss of life in 1848, but this was only partially successful. Further work was carried out in 1876 and the last major repairs were completed in 1906. Throughout the 19th century Wick's fame and prosperity depended on the herring industry, and, at its height in 1862, the harbour was used by 1,122 boats, employing 3,800 fishermen and 4,000 ancillary workers. It appears that today there is only one boat licensed for fishing, and this is only used on a part-time basis.

The monument in my view is to James Bremner CE, naval architect and harbour builder. Born at Keiss, he died in 1856.

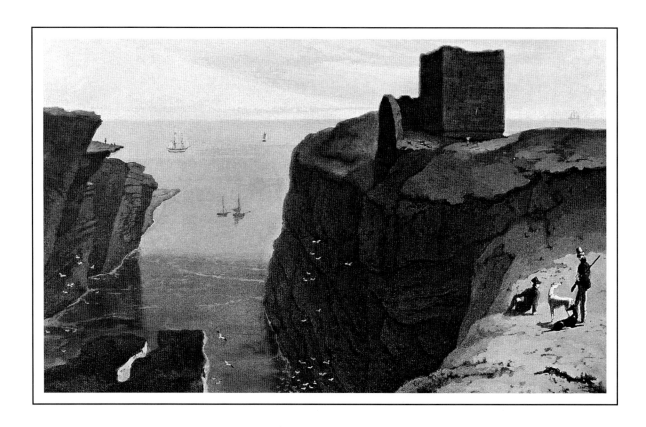

20 OLD WICK CASTLE

This castle is one of the strongest and most characteristic features of the north coast of Scotland. The jutting rock on which it stands is at a considerable elevation above the sea.

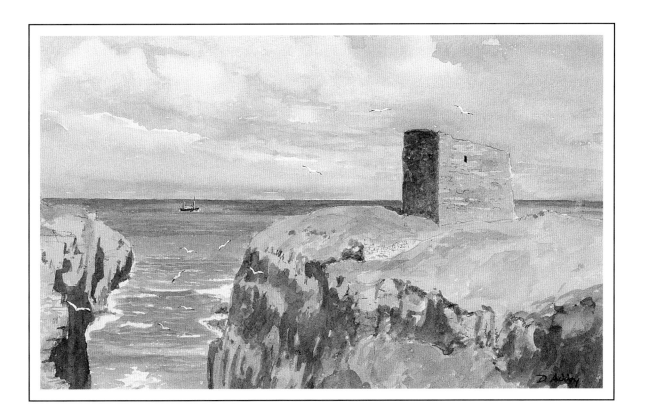

20 OLD WICK CASTLE

At the time of Daniell's visit, not much remained of this 12th century castle – one of the oldest in Scotland – and there is even less of it now. However, with its 7-ft thick walls, and under the care of Historic Scotland, the solitary tower should stand a little longer. This view and the two following views of Hempriggs are reached along a pleasant coastal path, but with the weather showing signs of deteriorating yet again, I did not have time to linger.

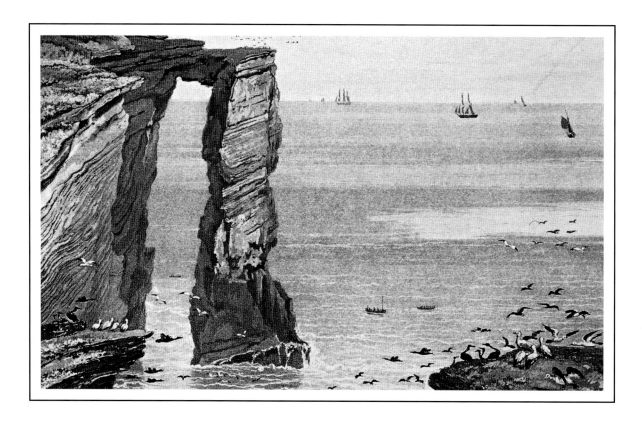

21 THE STACK OF HEMPRIGGS

This is a tremendously lofty natural bridge, over which it might seem the very extreme of temerity in any human being to venture. My two companions did not hesitate to ascend and place themselves in positions which would cause an involuntary shudder in persons unacquainted with the habits of men constantly residing on the coast.

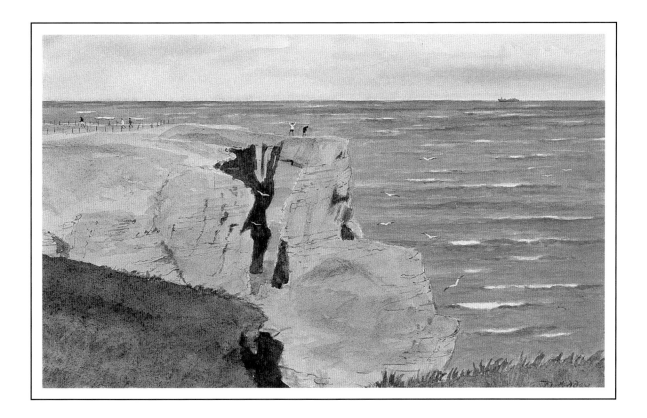

21 HEMPRIGGS STACK

This spectacular 'bridge' is still much the same, and, indeed, standing on it or viewing it from a distance certainly sent a shudder through me. I was surprised that Daniell did not show some figures on the bridge, but while I was there a group of runners made their way along the edge of the cliff, and two of their number obliged by standing on the bridge and waving to me.

After completing this view I had to find a bed and breakfast, which was proving difficult. However, similar experiences have confronted me before, but there is usually a satisfactory outcome. Eventually, I found pleasant accommodation in Wick but, embarrassingly, I could not understand a word that the landlady said. To this day I do not know whether I said 'no' when I should have said 'yes' or 'yes' when I should have said 'no'. Anyway, we seemed to come to some arrangement and I stayed for two nights.

22 SCENE AT HEMPRIGGS

Here is seen a cove in which herring boats are drawn up and people employed in barrelling the fish. The continual screaming of gulls and cormorants caused a harsh dissonance, which (if the Iricism may be pardoned) *accorded* well with the wild scenery around.

22 SCENE AT HEMPRIGGS

Daniell's view is from the water's edge, and although I could probably have descended to the same spot, it is doubtful if I could have climbed back up again. As there was no one else in the vicinity, I decided that the possibility of being marooned for some time was not an idea worth contemplating, and so I contented myself with the view from the top of the cliff.

When I first went into the house where I was staying in Wick, there were several watercolours on the walls that caught my attention. They were of good quality, and signed by modern artists whose names I recognised. Discreet enquiries revealed that they were copies that had been painted by my landlady, who said that she had put the original artists' signatures on them as she didn't want people to think that she had painted them – at least, I think that's what she said.

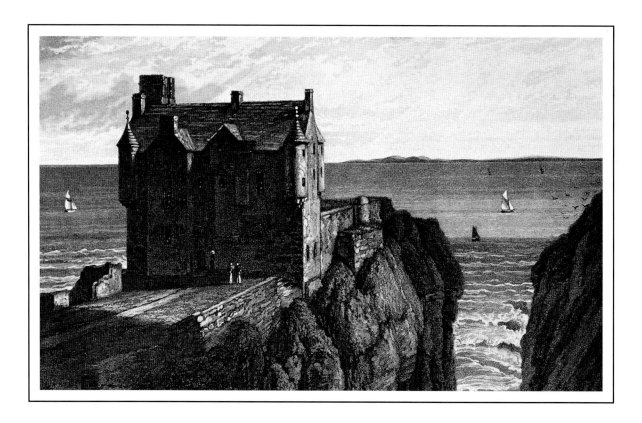

23 DUNBEATH CASTLE

This gloomy embattled mansion is said to have been the scene of some horrible transactions. Its portal might be inscribed with the motto from Horace Walpole's tragedy, which Mrs Radcliffe has prefixed to her Mysteries of Udolpho:-

'Fate sits on these dark battlements, and frowns:
And as I enter at the portal gates,
Her voice, in sullen echoes through the courts,
Tells of a nameless deed.'

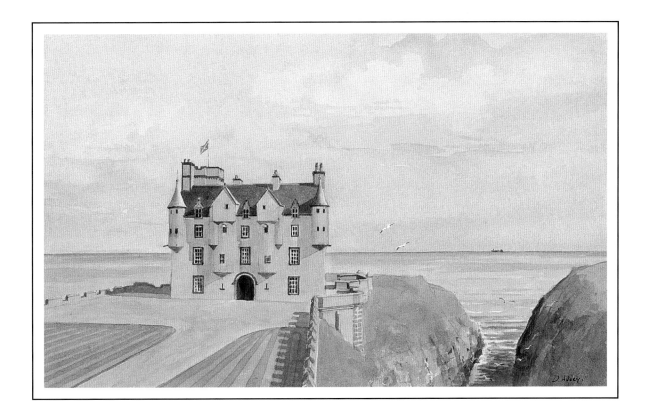

23 DUNBEATH CASTLE

Since Daniell's visit, two major reconstruction works have been carried out. The first in 1856-57 under the Edinburgh architect Thomas Hamilton, and the second in 1879-81 by another Edinburgh architect, John Bryce. From afar, I had caught sight of the castle on its cliff edge and subsequently approached it from Dunbeath harbour to obtain another view of it – where I also wondered about the 'nameless deed' referred to by Daniell. There were probably many nameless deeds in early castles but in 1669 the Privy Council despatched a strong force 'to pursue, apprehend and imprison William Sinclair of Dunbeath' for having 'invaded Sutherland, robbing, plundering and killing wherever he went'. Sinclair was obviously a rogue, and might well have been up to dark deeds in the castle.

The Mysteries of Udolpho, mentioned by Daniell, was published by Mrs Radcliffe in 1794, for which she received the sum of £500.

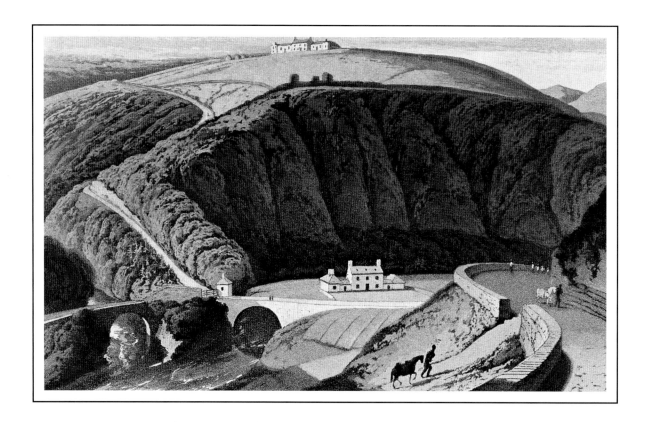

24 BERRYDALE

One of the most pleasing changes of scene that occurred on this journey was the first sight of Berrydale, looking from the road down upon two bridges; the inn with a finely wooded bank above it, and the summit of the hill crowned by the mansion belonging to Mr Horn, commands a fine view of the Moray Frith.

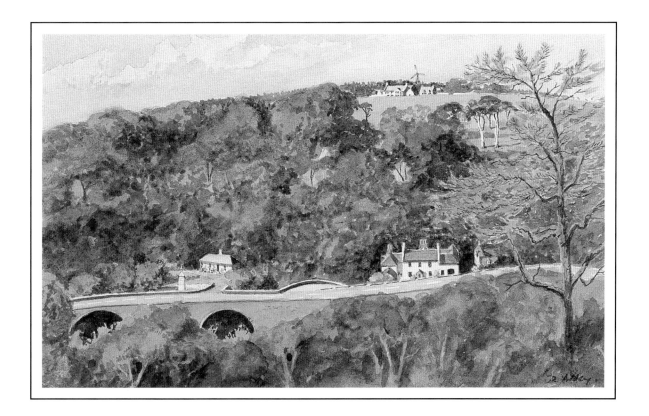

24 BERRIEDALE

Like a snake, the A9 winds its way across this dale, and it was from a lay-by near its summit that this view is taken. The basic features are the same as at the time of Daniell's visit with the two bridges, rebuilt in 1963, the coaching inn, converted into the estate office in 1850, and the mansion atop the hill behind which the wind generator was erected in 1986.

While working on my drawing I entered into conversation with a lorry driver who told me that on the first occasion he had driven his large pantechnicon down this hill, he had lost control of the vehicle, and it ended up in a bit of a mess. Certainly, to watch these large vehicles negotiate the hairpin bend just below the lay-by is a breathtaking experience.

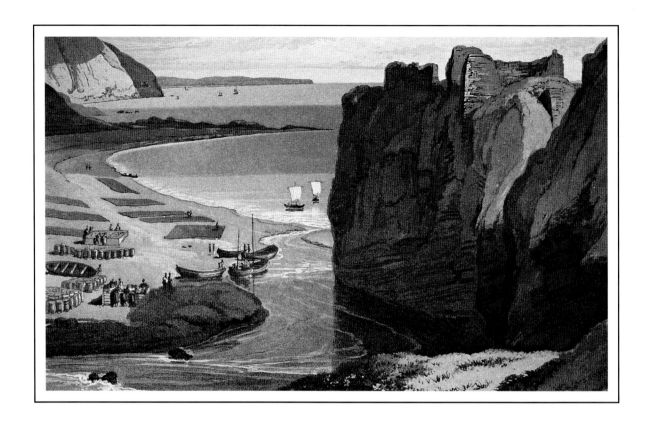

25 CASTLE OF BERRYDALE

The fine salmon stream of Berrydale flows into the sea, under this castle. The glen is very beautiful, and is plentifully sprinkled with wood, though of a small kind. There were some boats returning from a good night's fishing. Each boat was manned by four men, and had from thirty to fifty cran; the value of the cran being eleven shillings. During the season, which lasts six weeks, each boatman will earn about fifteen pounds.

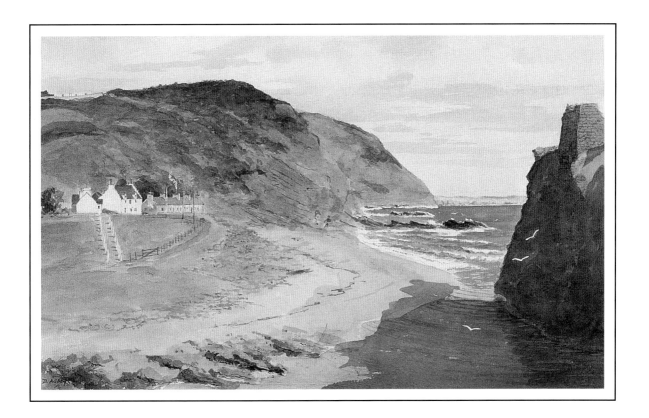

25 BERRIEDALE CASTLE

This was another of those occasions when it would have been advantageous to be a mountain goat to reach Daniell's viewpoint, and I had the utmost difficulty in sketching this scene. There were no safe footholds, and I dreaded the descent as, in situations like this, I usually end up on my backside. Frequently, I am not dressed for the occasion despite years of so-called experience. Nonetheless it was worth the effort. Only a few stones remain of the castle that was built by the Earls of Caithness. The cottages shown in my view are approached by an unusual pedestrian suspension bridge.

My exploration and enjoyment of the Caithness coast was made much easier by the assistance I received from the staff at the Heritage Centre at Dunbeath.

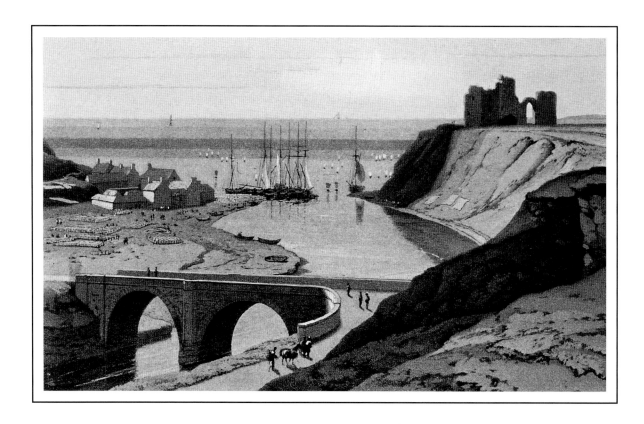

26 HELMSDALE

The situation of the ruined castle, on a hill commanding what the Welsh call the *aber,* and the French the *embouchure* of the Helmsdale river, is very striking.

The village is situated on the north-eastern side of the river, near its confluence with the sea, at the lowest extremity of Strath Helmsdale, called in the language of the country *Strath Ullie.* Though of very recent origin, it has become a fishing station of considerable importance. The two sides of the river are connected by means of a bridge of two arches, each of seventy feet span: this structure is on the line of the parliamentary road leading from Inverness to Thurso.

26 HELMSDALE

The modern road builders have been busy here, and the stones of the 15th century castle now lie under the embankment of the new bridge. In 1567 the castle was the scene of classic drama when a Countess of Caithness, planning to poison the Earl and Countess of Sutherland so that her son could become heir, accidentally poisoned her son as well. It seems to me that in days gone by the Scots were very keen on eliminating each other.

The quay shown in Daniell's view has totally disappeared, and there is now a small harbour on the east side of the new bridge. The two-arch bridge, which is still in use, was built in 1811; this was one of many on Thomas Telford's Great North Road from Dingwall to Thurso.

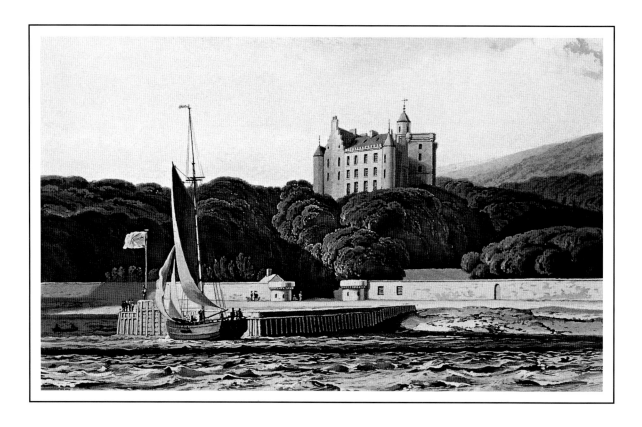

27 DUNROBIN CASTLE

The situation of the castle is singularly striking and beautiful. Standing on the edge of the wooded glen, upon a knoll of considerable height, and so steep as to be almost perpendicular, it seems to spring like a fairy palace from the bosom of the ocean. There is a splendid wildness in all around, which creates a sensation of remoteness from the haunts of ordinary life; yet this wildness is softened by the intervention of cultivated elegance, so as to enhance the grandeur and magnificence of this retirement, without giving birth to those less pleasing associations which separation from the busy world is apt to create.

Below the castle a pier was erected in 1812 by the Marquess of Stafford at an expense of £700, and other improvements and embellishments equally appropriate are in progress.

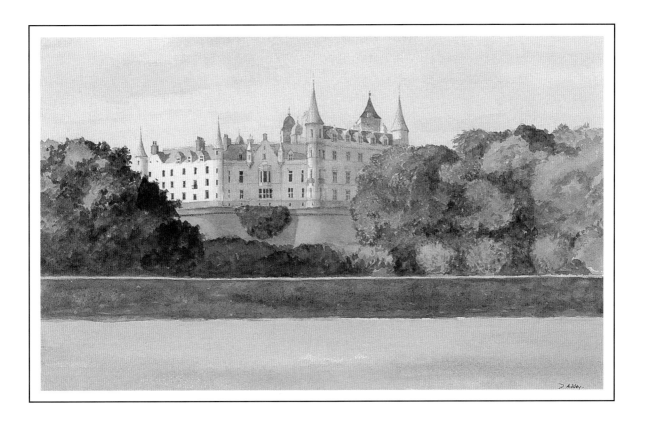

27 DUNROBIN CASTLE

I tackled this largest and most impressive castle on the east coast in total peace and perfect weather; this was just as well, as it was probably the most difficult subject to draw. One of Scotland's oldest inhabited houses, the castle has been the home of the Earls, later the Dukes of Sutherland, since the 13th century. Extensive alterations and additions were made to the castle in mid-Victorian times to the designs of Sir Charles Barry, architect of the House of Commons.

The timber pier shown in Daniell's view finally disappeared only a few years ago, and some remains of it are still in evidence. The stumpy turrets to the gateway depicted by Daniell exist, but are much farther to the left.

28 DUNROBIN CASTLE FROM THE N.E.

This view of the castle represents that structure at a greater distance. The circumjacent district has belonged to the Sutherland family from a very early period. They were governors of Sutherland before the year 1031, and became earls about the year 1061. The castle received its name from the founder *Robert*, the second Earl of Sutherland, 'Dun Robin' signifying the *hill of Robert*.

28 DUNROBIN CASTLE FROM THE NORTH-EAST

After having spent about three hours drawing the east elevation of the castle, this evening view from the coastal path to the north was a pleasant contrast. I sat upon a large, almost rectangular rock on the edge of the beach and I am quite sure that Daniell would have sat here also, as the composition of our two pictures is almost identical. The statue of the 1st Duke of Sutherland, by the English sculptor Sir Francis Chantrey, can be seen on the mountain at the right of my picture.

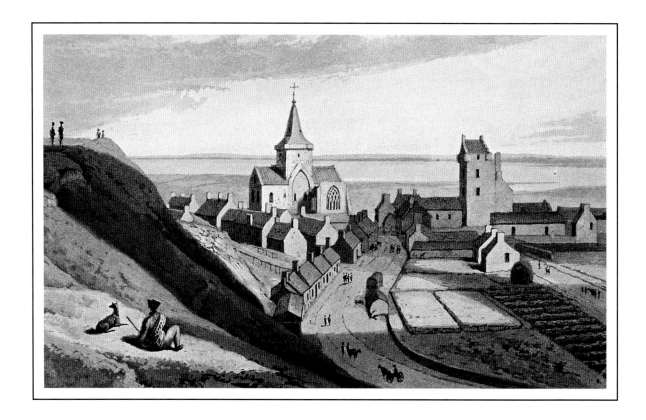

29 DORNOCH

Near the town, on the road leading to Embo, is erected a monument called the *Rie Cross* or King's Cross, in commemoration of a battle fought in 1259, between the Earl of Sutherland and a body of Danes, in which the latter were overcome. Their leader was slain by the Scottish chieftain with the hoof of a horse, to which he had recourse in his personal defence, having lost his sword in the conflict. From this incident the town assumed the arms of the earl surrounded with a horseshoe.

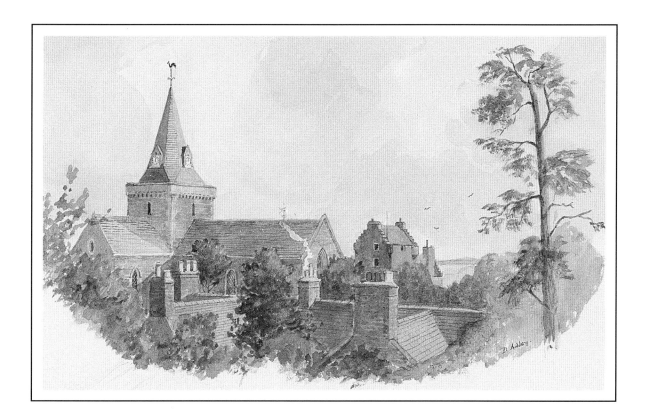

29 DORNOCH

Dull, wet weather greeted my arrival at Dornoch, and I had to wait until later in the day before I could find the viewpoint, which still exists but is surrounded by trees. I called at a nearby hotel in the hope of gaining a view from an upper window, but although I rang the bell on the reception desk a number of times, waited and wandered around, no one appeared. All I saw was what seemed to be a human form hidden behind a newspaper in the lounge – it moved not an inch and I decided to leave well alone.

The 13th century cathedral, largely rebuilt in the 19th century, is now the parish church. The remains of the castle (the old Bishop's palace) are incorporated in a hotel.

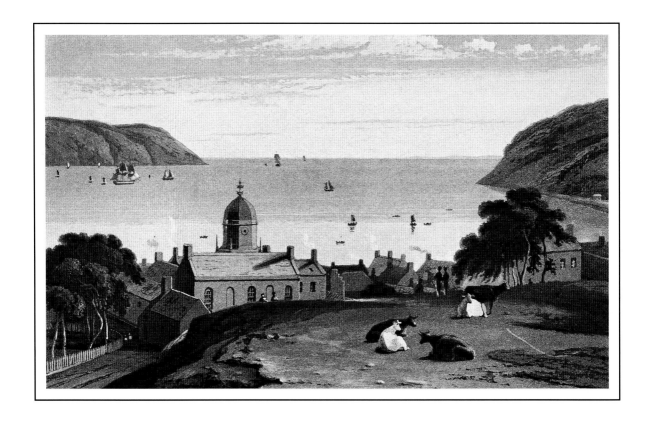

30 CROMARTY

The reader is to understand that the cupola belongs, not to any church, but to the town-hall; and it may be remarked, that, in all the towns of the north of Scotland, these municipal edifices are distinguished either by a cupola or a spire. The severe simplicity of the church of Scotland rejects such appendages to places of worship, as, at all events, superfluous, if not indicative of Romish usages.

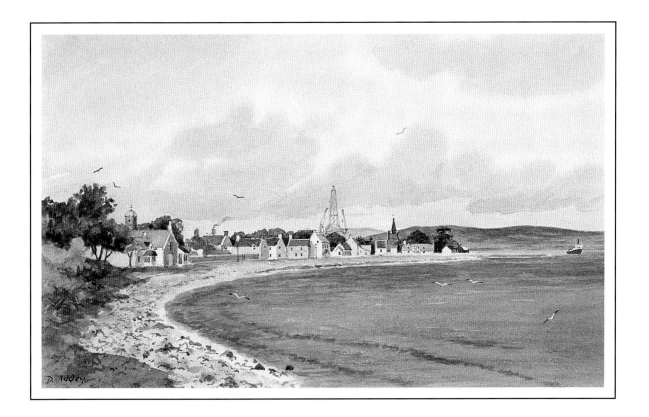

30 CROMARTY

The hill where Daniell sat is covered with trees, totally concealing the town hall, which is a prominent feature in his view. After walking along the front to the eastern end of the town, I found a pleasant spot to sit and do my drawing; this just shows the cupola of the town hall on the left. The strange structure in the background is one of the oil-rigs that are such a feature of this coastline today.

It was while discussing this painting with Her Majesty, Queen Elizabeth, The Queen Mother, who graciously visited one of my exhibitions, that I pointed out that the oil-rig was drawn in pencil. I explained that I had done this because, some people, while liking the view, might not like the oil-rig. 'Oh no,' Her Majesty replied, 'if it is there, you must show it'. So, by Royal Command, such objects will be included in future.

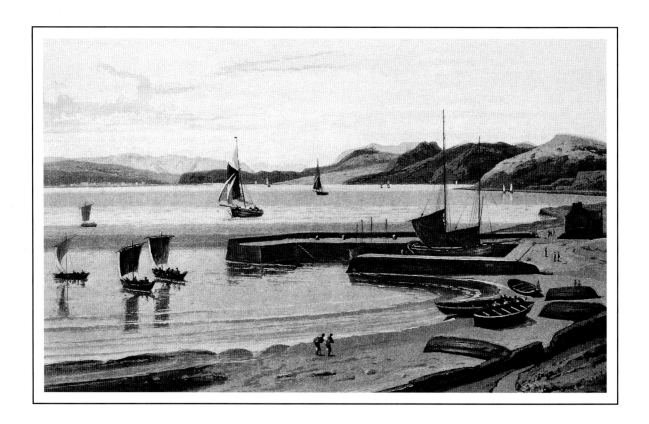

31 PIER AT FORTROSE

Fortrose is a borough situated on a narrow part of the Moray frith and consists of two towns, or villages, *Rosemarkie* and *Chanonry*. Only a small part of the cathedral now remains. A great part of the edifice is said to have been destroyed by Oliver Cromwell. The little masonry that remains is sharp and clear; the material is red freestone. The small pier, which is the principal feature in the view, has been recently erected. The prospect up the Moray frith as far as Inverness, which appears in the distance, is very beautiful.

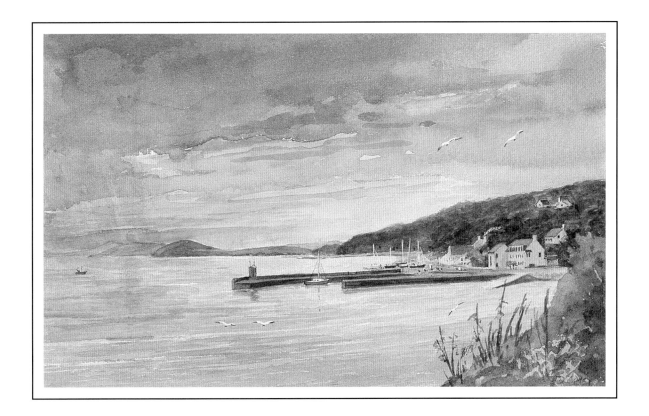

31 PIER AT FORTROSE

The weather was endeavouring to improve when I arrived here, but it was not being very successful. I just managed to do the necessary drawing before having to dive for cover as another cloudburst made its presence felt. My journey to Fortrose from Dornoch had been via Cromarty where the firth is crossed by the smallest car ferry I have ever seen. There is space for only two cars and these are parked on a turntable. On looking at the rest of my journey from here to Southend-on-Sea it appears that this was the last ferry on which I would travel – up to now the total was 55, with the first one being to the Isle of Wight. Subsequently, I discovered one more when I had to cross on foot to Orford Ness.

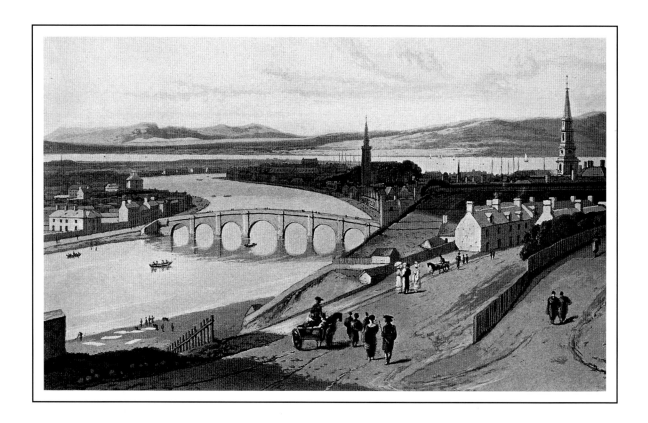

32 INVERNESS

The best general view of the scenery is from the hill on which stood the castle, not a vestige of which now remains. The two bridges over the river, and the Caledonian canal, which commences here, and since it was opened has given great animation to the place, are interesting objects. That the commercial intercourse of the place is rapidly increasing may be concluded from the single fact that a mail has been recently started for Wick and Thurso, to which this rapid vehicle of intelligence had never before penetrated.

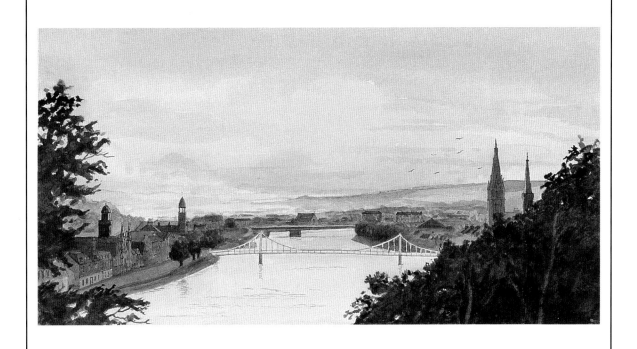

32 INVERNESS

This view is from the castle, which was built in the mid 19th century and is now the city's court-rooms and council offices. The spire, depicted by Daniell on the left, belongs to the Old High Church (1769-1772), while that on the right is the Town Steeple, built in 1791. These two spires still stand and are on the right of my view. The towers on the left bank are the West Church, built in 1840, and beyond that the Queen Street Church, occupied today by a firm of undertakers. The suspension bridge was built in 1882, and beyond this is the Friar's Bridge. The Ness Bridge, in Daniell's view, was replaced in 1962. Construction of the Caledonian Canal began in 1803, and it was completed in 1823.

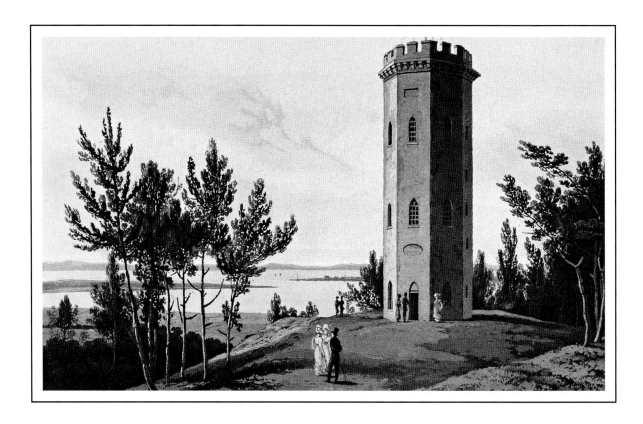

33 NELSON'S TOWER, FORRES

This tower was built by the gentlemen of the county, in commemoration of the victory of Trafalgar, by which the mighty admiral crowned his services to his country, and died in the blaze of his glory. The structure is simple, and the inscriptions on the tablets are equally so: they are such as he himself would doubtless have chosen; for he hated *parade*, and every other *word* and *thing* that was French.

33 NELSON'S TOWER, FORRES

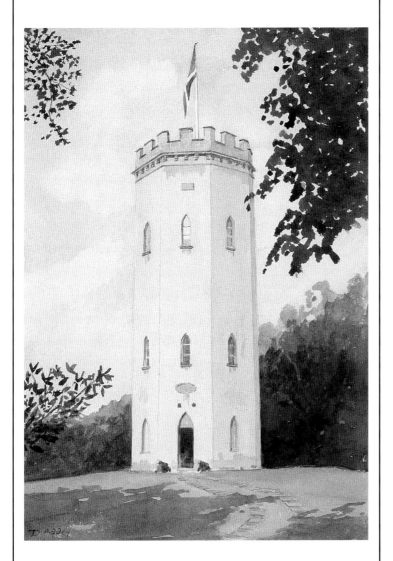

It is an exhausting climb to the foot of this tower, which was opened in 1812. Then, if you are fit enough, there are a further 96 steps to its roof-top, from where there is a fine view over the surrounding countryside. Also at Forres there is an ancient obelisk, the Sueno Stone, which Daniell depicted. Unfortunately, it has been encased in a large glass and aluminium 'box' so that it has lost all sense of spiritual isolation. When I commented on this to the keeper of Nelson's Tower he said that it was not so much to protect it from the weather but from vandalism. 'Go and look at the outside of this tower' he said, and to my horror I saw that it was covered with graffiti.

I duly completed my sketch and made my way down to the lower levels – only to fall flat on my back and any dignity I had evaporated in seconds.

34 COXTOWN TOWER, NEAR ELGIN

This tower is a good specimen of the ancient fortified residences erected in this once agitated country, in those ages when clanship and vassalage created perpetual subjects of feud between tribes and even families.

34 COXTON TOWER, NEAR ELGIN

Here is a subject that remains almost exactly as Daniell saw it. A delightful, simple tower constructed entirely of stone, including all the floors and roof. The date on the panel over the door is 1644, which is when it is assumed that the tower was completed. In 1535 an Act of Parliament required every owner of land over a certain value to build a tower or castle to defend his property, and this one is in its largely original state. It stands in a private garden and, as on many previous occasions, access to it was readily given.

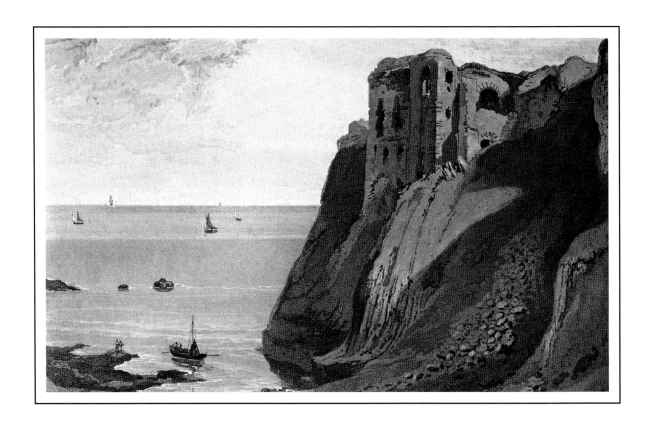

35 FINLATER CASTLE

The castle is situated on a peninsulated rock of no considerable height, the surface of which has been so completely covered with buildings, that the outer walls, especially those fronting the sea, precisely correspond with the front of the precipice. The apartments are strongly vaulted, and have large windows which look into the sea. This remote stronghold was relinquished by the noble family of Findlater, about the end of the reign of James I of England, when, like others of the nobility, they chose more commodious residences in a more inviting part of the country.

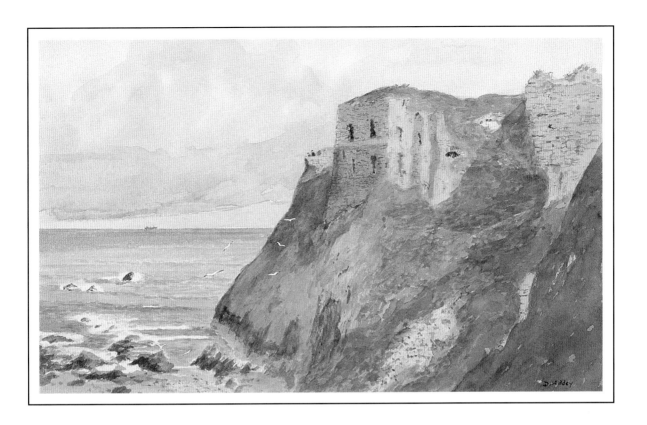

35 FINDLATER CASTLE

The castle ruins remain largely as depicted by Daniell, and there was no difficulty in finding his viewpoint. For my exploration along the Moray coast I stayed in an inn at Cullen which, like the other small settlements in the area, is now but a shadow of its former life as a fishing community.

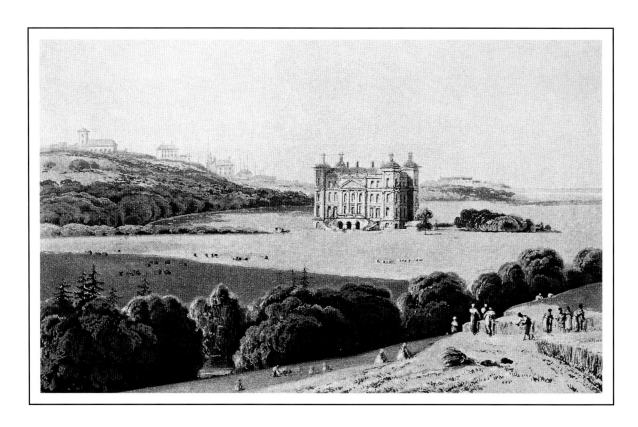

36 DUFF HOUSE, BANFF

Duff House, the mansion of the Earl of Fife, is a quadrangular edifice, of modern or rather Grecian architecture. Some antiquaries might doubtless have preferred a castellated structure, as a more appropriate residence for the descendants of the thanes of Fife; but allowing the aptness of such a reminiscence of past ages, few persons of taste will be disposed to regret the substitution of classic elegance for feudal grandeur, in a pile of such magnificent proportions.

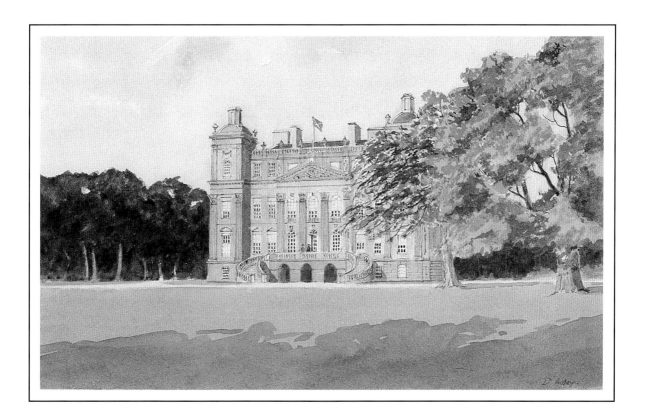

36 DUFF HOUSE, BANFF

Daniell's view of Duff House is now totally obscured by trees. I decided to find a lower and closer viewpoint so that I could enjoy drawing the architectural features of the house. Unfortunately, after I had completed this, I found that it was totally out of proportion, and so I had to start all over again – a complete waste of two hours. My excuse for this was that chattering on-lookers who, although pleasant and interesting, had seriously upset my concentration.

The house, designed by William Adam (1689-1748), was commissioned by William Duff (1697-1763), Lord Braco, and the foundation stone was laid in 1735.

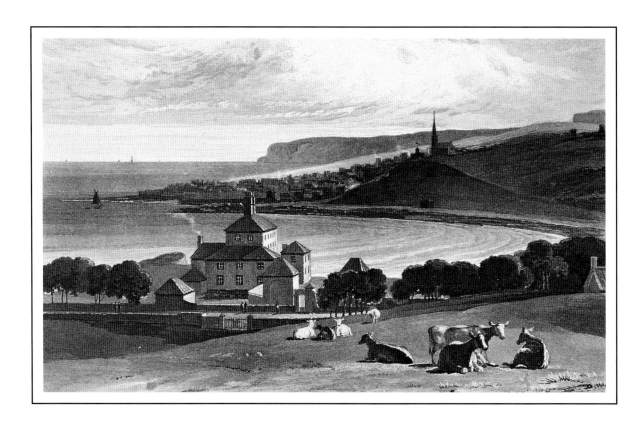

37 BANFF

Banff is of considerable antiquity and, according to tradition, was founded in 1163. Several of the streets are well built, and there is a general air of respectability about the place, which does not uniformly characterise the maritime towns of the more northerly districts of Scotland. Its site is on the declivity of a rather steep hill, near the mouth of the romantic river Dovern, over which there is a handsome bridge of seven arches.

The harbour was formerly rendered very incommodious by the continual shifting of the sand-banks at the mouth of the river; but it has received some improvement by the formation of a tolerably good pier.

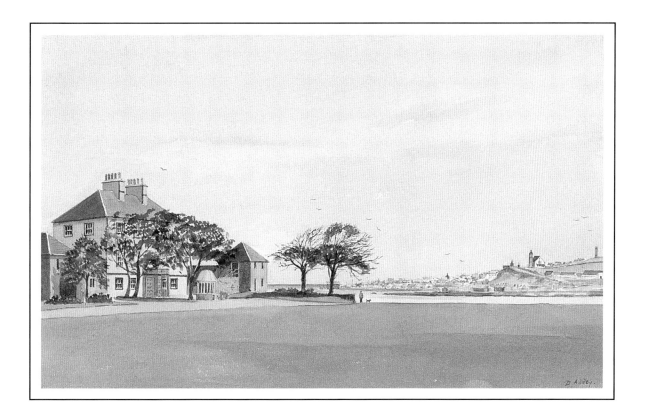

37 BANFF

I searched high and low for this view, but a housing estate now sprawls over the land where the cows are grazing in Daniell's scene. Nonetheless the large building, known as Banff Castle, still exists, and it was in its grounds that I finally settled down. Designed by William Adam's eldest son, John (1721-1792), this mansion was built in 1750 for Lord Deskford alongside the mediaeval castle, which was demolished in 1820. Two-storey pavilions flank the tall pavilion-roofed building, and the domed well in the forecourt was added in 1926. Today, the castle is owned by the citizens of Banff, and used for community functions. The town of Macduff lies in the distance on the other side of the River Deveron.

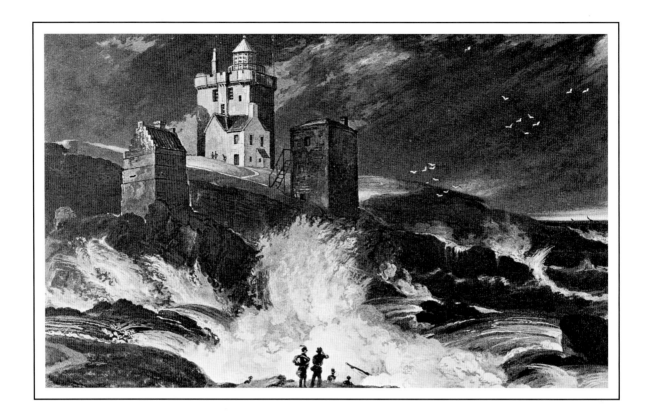

38 KINNAIRD HEAD

The castle and lighthouse are one and the same building. The beacon is of the utmost importance to vessels navigating these seas, as the coast is particularly dangerous in those seasons of the year when storms are most frequent

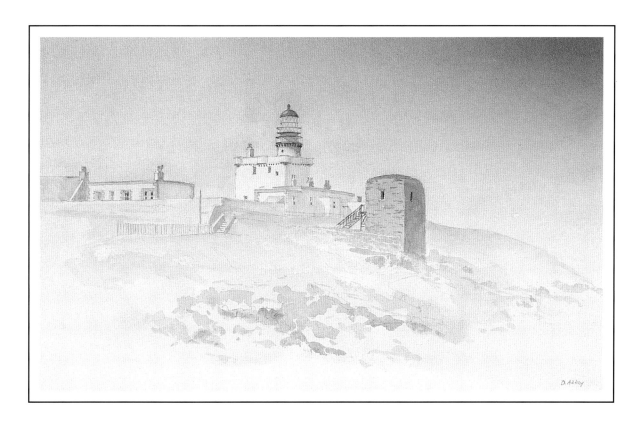

38 KINNAIRD HEAD, FRASERBURGH

The evening before I reached Fraserburgh I had been at Crovie where a fine, clear sky gave promise of another good day to follow. But as I approached Fraserburgh my spirits sank when I saw thick fog rolling in off the sea. Eventually I found the lighthouse and, although my viewpoint was less than 150 yards away from it, the superstructure was totally obscured. I waited impatiently for at least an hour before a brief break in the fog gave me a few moments to set down its details. This was the beginning of four days of frustration.

The lighthouse, designed by Thomas Smith, and the first to be built by the Northern Lighthouse Board, was established in 1787 and automated in 1991. Nearby there is an excellent lighthouse museum with a pleasant small restaurant.

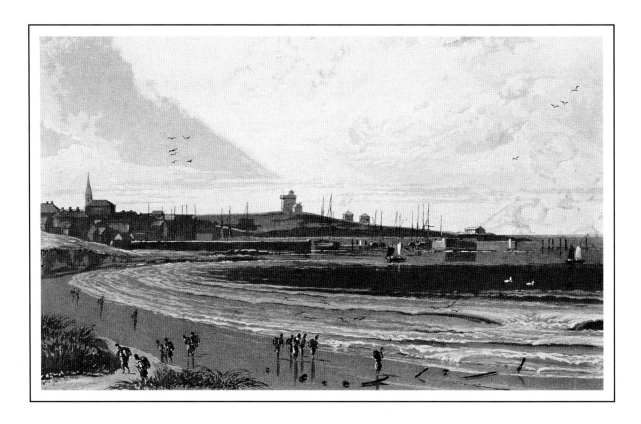

39 FRAZERBURGH

Frazerburgh is a small port and has a tolerably good pier; and the harbour, though small, is commodious for vessels of three hundred tons, and well situated for the herring fishery, which is here carried on with great spirit. A considerable quantity of linen yarn is manufactured here, but the chief dependence of the town seems to consist in the fishery.

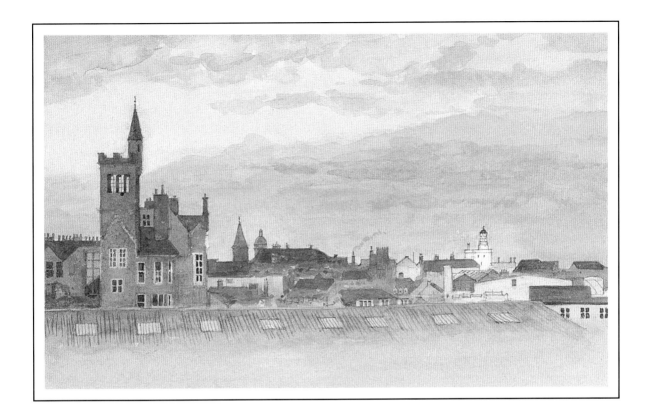

39 FRASERBURGH

My first visit here was a total waste of time. The persistent fog precluded all attempts at work and I had to return later. The situation was the same at Peterhead and Slains Castle. Ironically, when I found myself in front of the scene here and at Peterhead, I rather wished that the fog had persisted; there has been so much thoughtless development along their waterfronts. The large building on the left of my view is known as the Dalrymple Hall and Arts Centre where flower shows, travelling entertainments, arts and crafts exhibitions, etc., are held. In Daniell's view the two buildings with pyramidal roofs were dovecots, and the building at the right-hand end was the fever hospital.

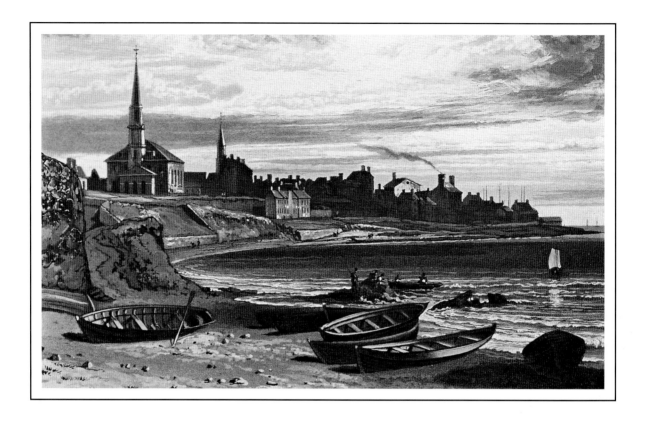

40 PETERHEAD

The houses in the town are mostly built of granite of excellent quality, which is found in the neighbourhood: vast quantities are shipped here for England. Near the head of the principal street is an elegant town-house, with a spire one hundred and ten feet high. The old harbour was originally a shallow cavity in the rock, in which boats only could find shelter, and to which the entrance, both from the north and south, was very dangerous.

The attractions of Peterhead as a watering-place arise not only from its conveniences for sea bathing, but from the waters of a mineral spring, called the *Wine Well*, situated to the southward of the town. The water is considered very beneficial for disorders of the stomach and bowels, nervous affections, and general debility.

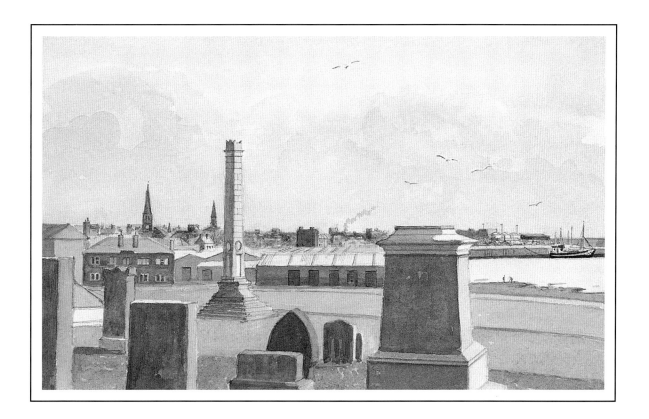

40 PETERHEAD

It is a pity that this town has been developed so intensively, as the waterfront in Daniell's view appears to have been most attractive. But, as at Fraserburgh, the needs of the fishing industry have had to be met and, consequently, the harbour, with its associated buildings, is now a considerable size. However, the two buildings with spires still exist, the nearest being the Old Parish Church, which was built in 1770. As a result of subsidence, it was rebuilt on a new site in 1806, and is still used today as the parish church. The second spire is the Town House, built in 1788, now occupied partly by the council and a local firm of solicitors. The War Memorial, erected in 1922, is situated in St Peter's Church Yard.

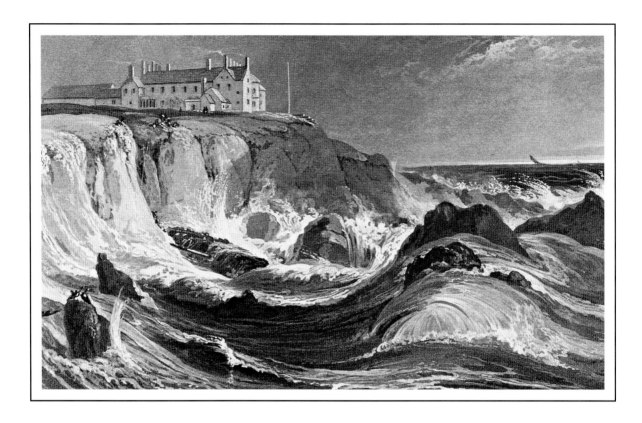

41 SLANES CASTLE

This romantic structure is built on a perpendicular rock whose base is washed by the sea; which, agitated by a high wind, wore an aspect of terrific grandeur, especially when contrasted with the stern repose of this firmly founded mansion. The rocks in the neighbourhood of the castle are in general lofty, and by the continued action of the sea for ages, have been indented with deep and awful chasms, and in some parts excavated to a considerable distance.

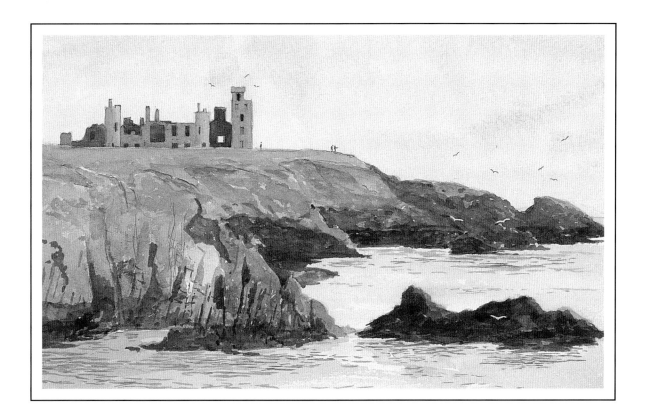

41 SLAINS CASTLE

These gaunt ruins could well have been Count Dracula's lair. Perched on the edge of precipitous cliffs and shrouded in thick fog when I first saw it, the castle was built by the 9th Hay Earl of Errol after his castle at Old Slains had been destroyed by James VI in 1594. Major alterations were carried out in 1664, and the castle was substantially rebuilt in 1836. Sold by the Hays in 1916 the castle was partially demolished in 1925. A small plaque – a sobering reminder of the dangers along this treacherous coast – marks a recent tragedy, when a young boy fell over the cliff and died.

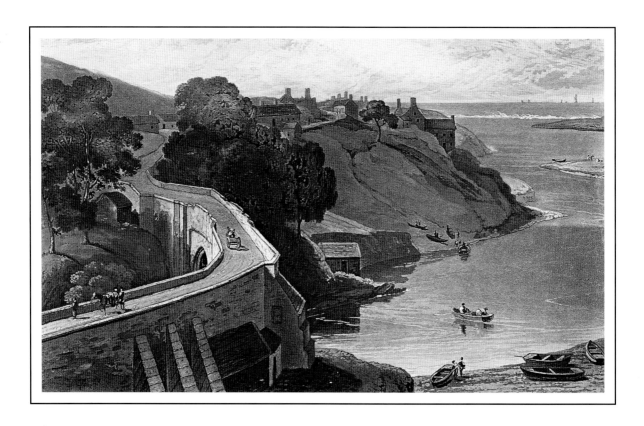

42 BRIDGE OF DON, OLD ABERDEEN

It will be seen in the view here presented, that across the mouth of the river there extends a bar, over which however vessels can pass at high water, and come up to take in flour at the mills erected on the banks below the bridge. On the bridge there is a Latin inscription, bearing the date 1605, and stating that Alexander Hay had granted the annual sum of twenty-seven pounds Scots for keeping the structure in repair.

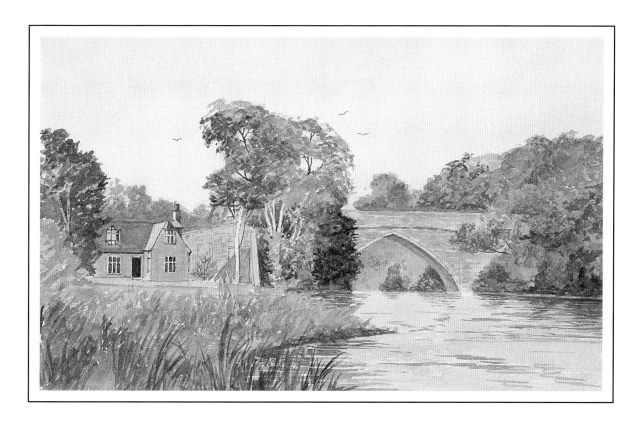

**42 BRIDGE OF DON,
OLD ABERDEEN**

Daniell's view of this fine old bridge, now only used by pedestrians, is totally obscured by trees, and even the view that I have drawn was difficult to find.

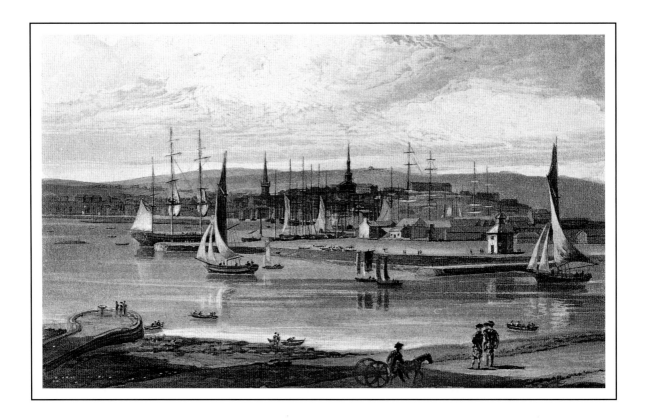

43 ABERDEEN

The harbour is situated at the bottom of an eminence, on which stands the bridge; it is a sort of curved inlet, partly separated from the river by a low island. The access to it was formerly interrupted and rendered precarious by a continually shifting sand-bank: but the inconvenience has been remedied by the erection of a pier, on a plan communicated by the late Mr Smeaton.

The chief imports to Aberdeen are from the Baltic and West Indies; and there is much intercourse between this port and that of London, where the salmon fisheries of the Don and the Dee find an advantageous market. The principal exports are stockings, thread and grain.

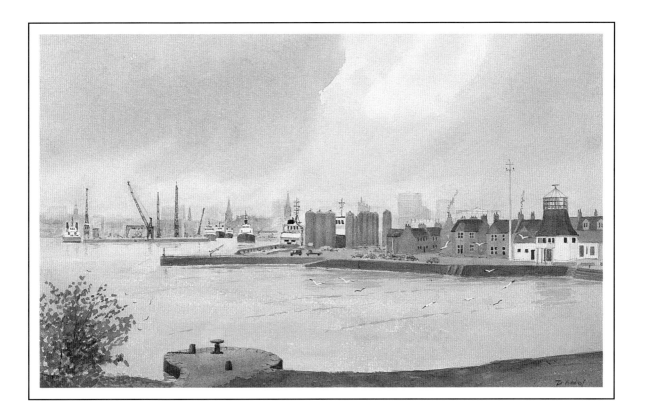

43 ABERDEEN

Fog persisted for a third day along this stretch of coast, and it was with considerable difficulty that I was able to see the city from Daniell's viewpoint. Inevitably, there have been many changes, but the small jetty in the left foreground of his view still exists.

Despite the apparent isolation of this spot, there were a number of people wandering around; it transpired that they were bird watchers. I was curious to know wherein lay their interest and was told that it was the small tree, which is shown in my view. Apparently, this is one of the first trees that birds find when they are migrating from the Continent, and on this particular day, the tide and wind provided ideal conditions for the arrival of several species.

This seventh stage of my Voyage was completed on 24th September 1999.

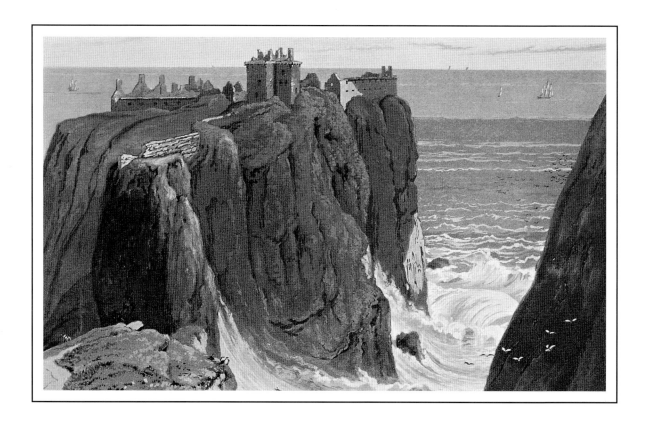

44 DUNOTTER CASTLE

This is one of the most striking objects of antiquity on the east coast of Scotland. The entrance to it is through a gate in a wall about forty feet high, whence by a long passage, partly arched over, there is access, through another gate, pierced with four loopholes, into the area of the fortress, which measures about an acre and a quarter. This passage was formerly fortified by two iron port-cullises. The area is occupied by buildings of different dates; the oldest, except the chapel, is a square tower, said to have been erected at the close of the fourteenth century. There is a large range of lodging rooms and offices, and in particular a forge, said to have been used for casting bullets.

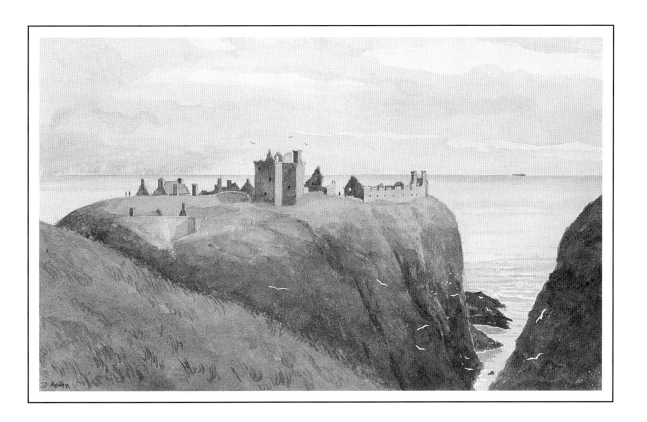

44 DUNNOTTAR CASTLE

The eighth stage of the Voyage began here on 20th August 2000.

A scene almost unchanged since Daniell's visit, but no doubt with many more visitors than in his day. I had chosen a Sunday so could not expect to have the place to myself, but I was surprised at the number of people crawling all over the place. It was even more surprising to find three other artists at work; a rare sight and only the third time in all my travels round the coast that I had seen anyone else working *en plein air*.

The main road past the castle had a 'Road Closed' sign, but I decided to ignore it and drove on. I was glad that I had done so as there is a fine view overlooking the attractive harbour of Stonehaven.

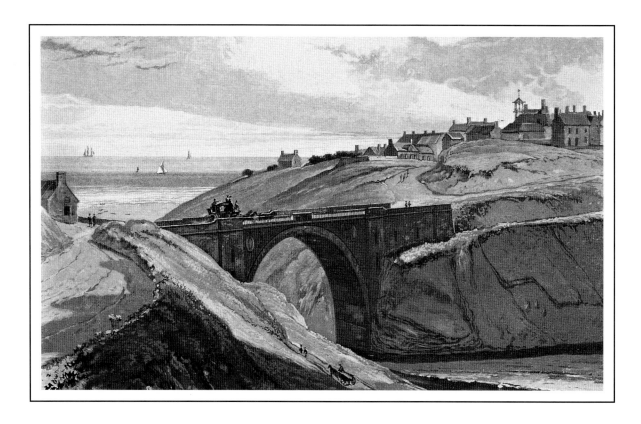

45 INVERBERNIE BRIDGE

Inverbervie is a dull little village of which the bridge is the principal ornament. The mouth of the river forms a small harbour for fishing boats. However regular may have been the original plan of the place, it seems to have been strangely neglected, and the houses stand confusedly, as if each had been reared by a separate owner, who chose to indulge his own whim without regard to his neighbours.

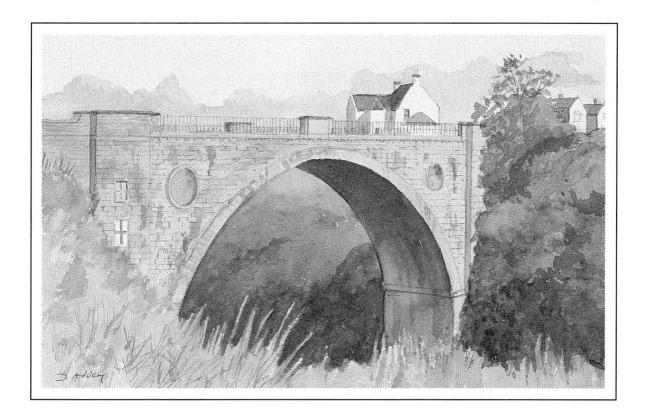

45 INVERBERVIE BRIDGE

Only pedestrians now use this old bridge, which was completed on 20th September 1797 and replaced the previous one built in 1696. It is said that prisoners were kept in small cells in each of the piers. Its construction was 'proposed and ably supported by the exertions of the lately deceased Robert Barclay Allardice, Provost of Inverbervie and MP for Kincardineshire'. Allardice was a remarkable man and on one occasion walked 1,000 miles in 1,000 hours. The new bridge, which is conveniently hidden from this viewpoint, was built in 1935 and is called the Jubilee Bridge. I have to confess that I had drawn my original sketch on the back of another drawing – a deed that is extremely irritating and a total waste of time. This is the second occasion that this happened on the Voyage.

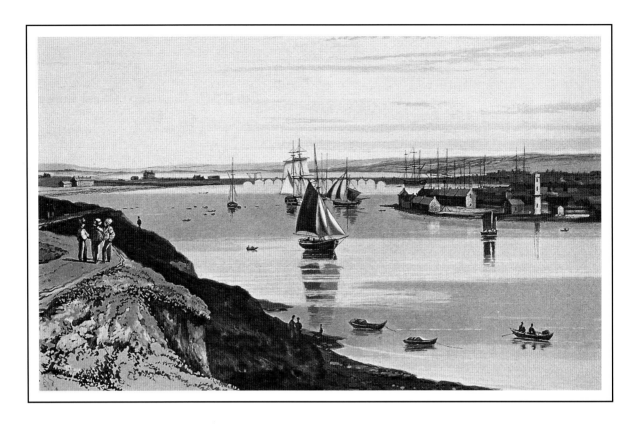

46 MONTROSE

The harbour is very commodious, and there is plenty of water over the bar to admit vessels of good size. Here are a dry and a wet dock for building and repairing ships: those belonging to this port are principally engaged in the coasting and Baltic trade. The town is neatly built, and is distinguished rather as a place of retirement for persons in independent circumstances, than as a mart of commerce. It has a handsome parish church, an episcopal chapel, two town-houses, and several hospitals and charitable institutions; there are also an extensive public library, a theatre, and other places of amusement. The communication with the country to the southward, which was formerly effected by the inconvenient and precarious intervention of a ferry-boat, has been improved and secured by the formation of a good bridge over the South Esk.

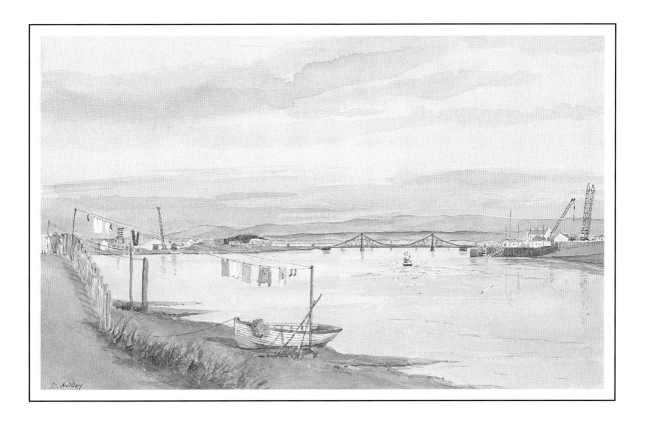

46 MONTROSE

This was an early morning scene from almost exactly Daniell's viewpoint. The bridge depicted by him was built in 1792, replaced by a suspension bridge in 1828, and the present concrete bridge, opened in 1931, followed this. The railway-bridge beyond was built in 1881. At first I thought that the poles and lines formed a makeshift contraption for catching fish, rather like I had seen in the Far East, and I was a little surprised when I saw that they were used for hanging out the washing.

I had found a more interesting view higher up, which included a row of cottages in the foreground. Just as I was about to settle down, an early morning milkman warned me that I would probably be shot by a nearby house-owner if I dared to so much as set foot in the vicinity. I decided that the slightly better view was not worth the ultimate sacrifice.

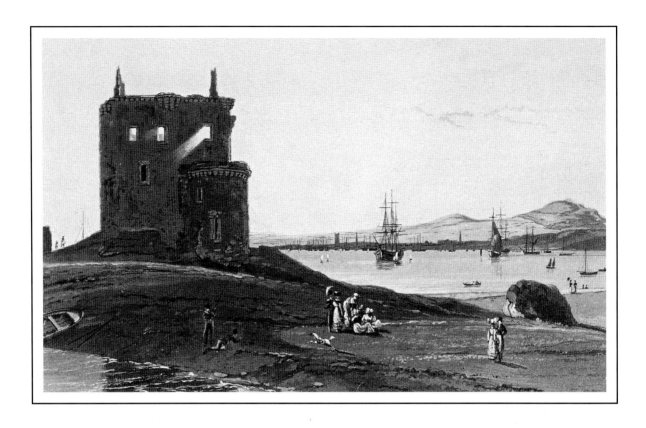

47 BROUGHTY CASTLE

The castle is a ruin which stands on the northern promontory of the entrance to the frith of Tay. It belongs to the Kyd family, but no particular circumstances concerning its history were to be collected; as a coast feature, it could not justly be passed without notice.

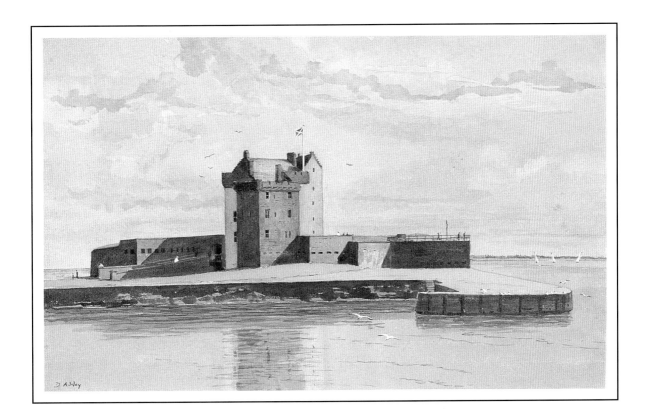

47 BROUGHTY CASTLE

This was the hottest day on this stage of my travels, when it was a pleasant change not to have to battle with crowds, rain, fog or gales. The castle was a military establishment and a coastal stronghold from 1547 to 1945, being extensively restored between 1858 and 1860. After the Second World War it became a railway storage depot and later a tea room, but now, in the care of Historic Scotland, it is used by Dundee Corporation as a museum.

Daniell completed his extensive tour of 1818 at Dundee and it was on 4th August 1821 that he resumed his travels at St Andrews.

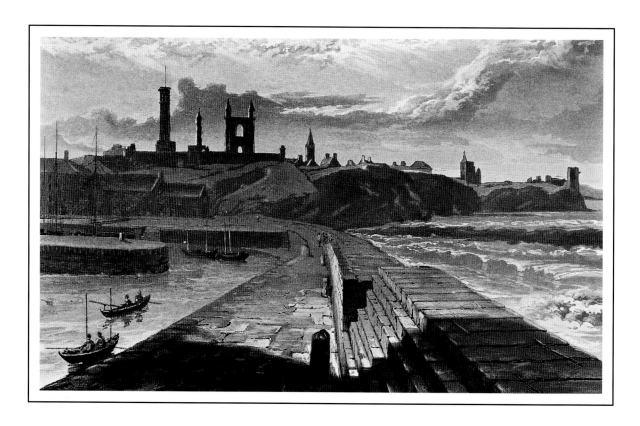

48 ST ANDREWS

St Andrews is chiefly remarkable for its venerable
antiquity. The ruins, in a picturesque point of view,
are seen to the greatest advantage from the farther
end of the pier. An air of stillness and melancholy
pervades the place: no trade seems to be carried on,
and only a solitary vessel or two were to be seen in the
harbour. The remains of ecclesiastical magnificence,
which this place exhibits, the magnitude, and
apparent grandeur of the buildings, so dispro-
portioned to the scanty population, and to the little
stir or bustle among them, suggests the idea of a city
too large for its inhabitants, and produce a saddening
effect on the spirits, something akin to the feeling
which oppresses a traveller in surveying a capital in
ruins.

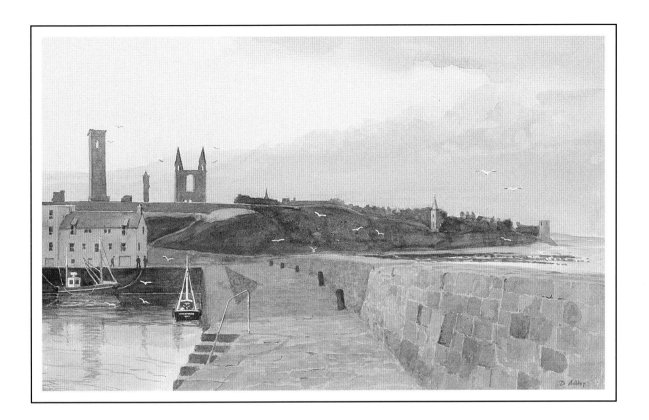

48 ST ANDREWS

I could not believe my eyes when I first saw this view. Although the distinctive skyline of ancient ruins dominates it, there is on the quay at the left-hand side the most hideous four-storey, grey, flat-roofed building of which the developer and planning authority should be thoroughly ashamed. Built in the 1970s between two lower buildings, this monster dominates the quay and should never have been permitted. Apart from this horror, St Andrews has a wealth of interesting material with the old castle ruins and nearby buildings being particularly attractive.

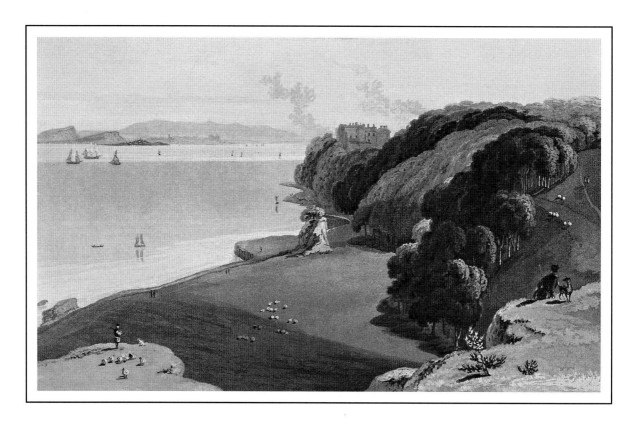

49 DISTANT VIEW OF EDINBURGH, WITH WEMYS CASTLE

The castle is built on an extensive scale, and has a very imposing effect; the wood around it is good and plentiful. In the grounds there are several caverns: one in particular, about mid-way to East Wemyss, is remarkable for its dimensions, being fifty yards long and twenty-five wide. The mansion commands an extensive view of the frith of Forth, backed by a fine range of scenery, extending from the Bass Rock to Arthur's seat, and thence far away to the westward.

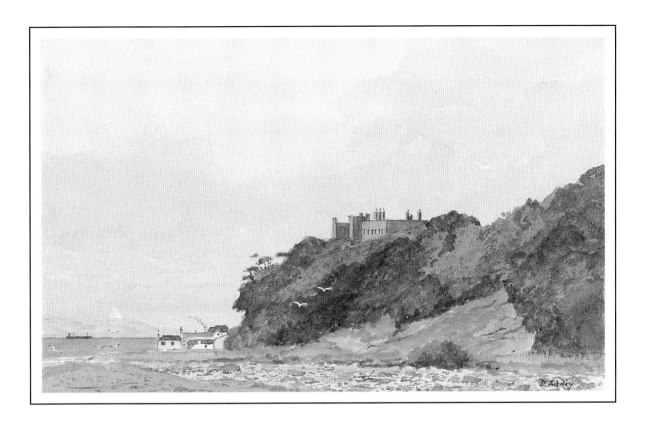

49 DISTANT VIEW OF EDINBURGH, WITH WEMYSS CASTLE

Pronounced 'weems' the name is derived from the Early Gaelic for 'cavern'. Daniell's viewpoint is now totally overgrown with trees and undergrowth. To see the castle I had to find a position near the solitary rock, which he shows in the centre; this is included on the right-hand side of my painting. A few buildings in the village of Tolbooth can be seen on the left.

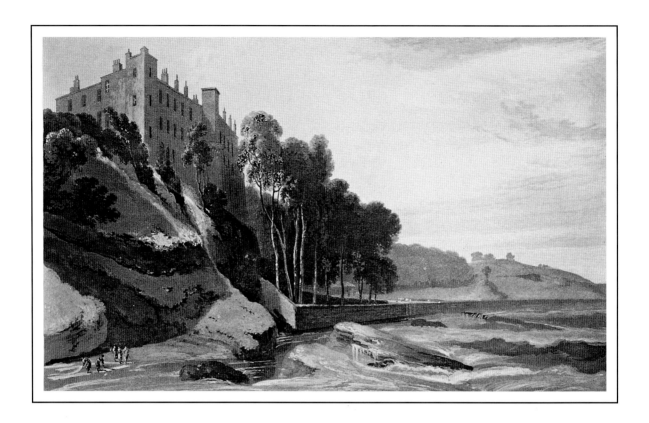

50 WEMYS CASTLE

It may be interesting to remark, that in this castle Lord Darnley had his first interview with Mary Queen of Scots, on the 13th February, 1565. That princess was then on a visiting progress through the county of Fife; and so profuse was the hospitality to which her presence gave rise, that provisions of every kind rose to an enormous price, and, according to the testimony of that severe censor John Knox, partridges were sold at a crown a piece.

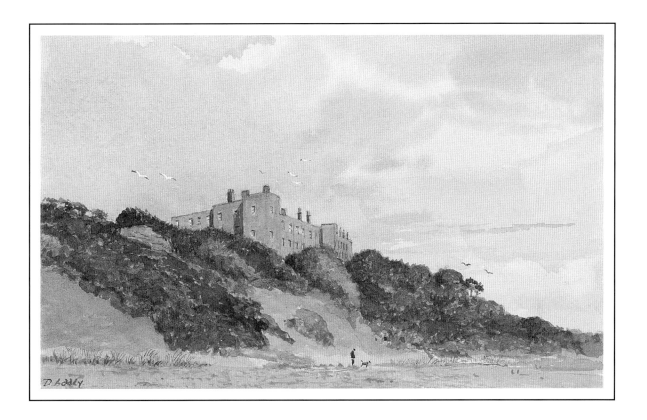

50 WEMYSS CASTLE

There has been little change to the stark façade of the castle since Daniell's visit, and I was able to find his viewpoint without any difficulty. My problems arose shortly after I had started my drawing when a sudden cloudburst found me totally unprepared and without shelter. All I could do was to cover my head with the drawing board but, in so doing, the partially finished drawing was completely ruined. I had to return some days later to complete my task.

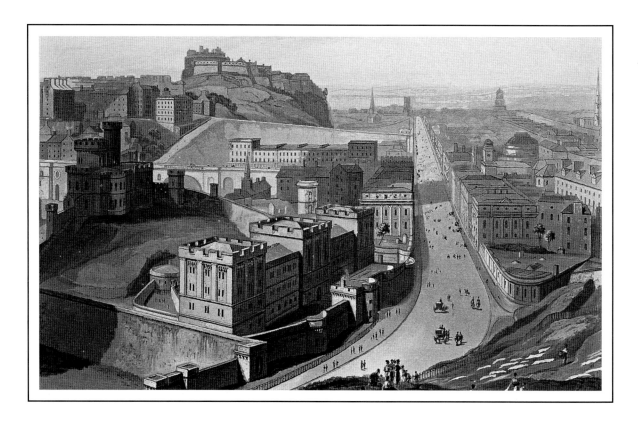

51 EDINBURGH FROM THE CALTON HILL

It may be proper to notice some recent improvements which have so changed the aspect of this quarter of the town, that a native returning after an absence of some years, would here feel himself almost in the predicament of a stranger. The approach to Edinburgh by the great London Road had long been a subject of general regret, as it lay through obscure, narrow, and inconvenient streets, not at all in accordance with the general elegance of the place. In 1814 active measures were adopted to remedy this defect, by forming a magnificent entrance from the eastward. The Calton Hill, in itself a singularly striking and romantic object, has been laid out in such a manner as to enhance its picturesque effect, and harmonise with the other improvements.

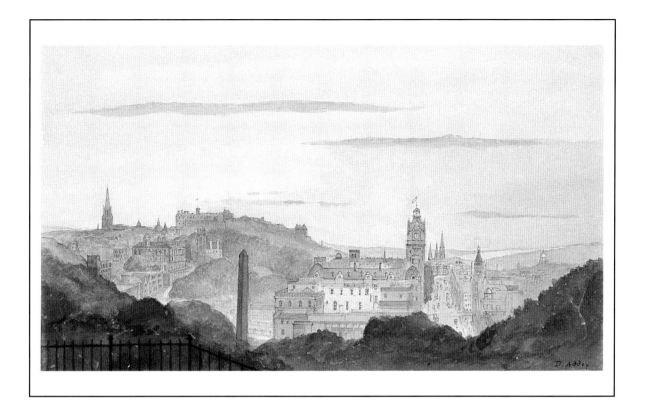

51 EDINBURGH FROM CALTON HILL

This was a particularly difficult subject to tackle, not only for its complexity, but the weather had been cold and wet – and I was surrounded by swarms of Germans and Japanese. I had started late in the afternoon, and not really given myself sufficient time to complete the drawing. The prison, prominently in the foreground of Daniell's view, was demolished in 1936 having been vacated a decade earlier. In my view the monument is the Martyrs' Memorial erected in 1846. The spire in the left distance was the former Tolbooth Church and Church of Scotland Assembly Hall completed in 1844. Today it is the headquarters of the Edinburgh International Festival and is known as The Hub. The clock tower stands above the Balmoral Hotel, which was formerly the North British Hotel, completed in 1902.

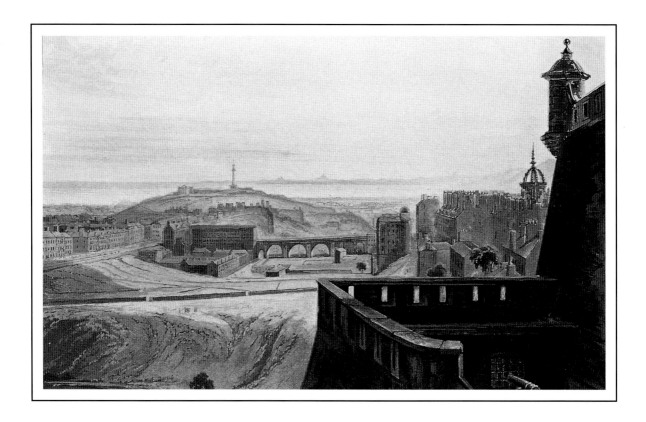

52 EDINBURGH, FROM THE CASTLE

Below the turret on the right is seen the spire of the cathedral of St Giles. The mass traversing the front is the Earthen Mound, on which is built a wall of convenient height, to screen passengers from the wind when blowing along the North Loch in either direction: it has a walk on each side. To the left is seen part of the front of Princes Street, and the range of houses bounding the North Bridge. Beyond them is seen the Calton Hill, on which appear Nelson's monument, and, a little to the left, the Observatory. The latter structure was founded in 1818, in order, as is expressed on the plate deposited at the foundation, 'that a great city, renowned for luxury and knowledge, might be no longer without the means of cultivating the most sublime and perfect of the sciences.'

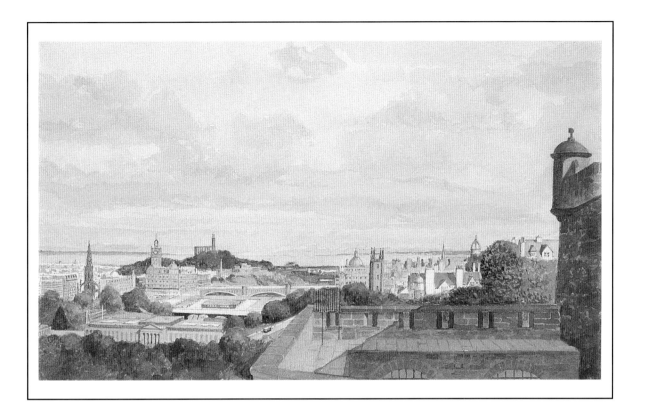

52 EDINBURGH, FROM THE CASTLE

It was not difficult to find this viewpoint but, to my dismay, it was out-of-bounds as construction work was being carried out. After fortifying myself with a cup of tea, I approached a castle attendant, explained my predicament, and after she had had 'mobiled' consultations with the management, I was allowed to enter the forbidden territory. It was assistance such as this that has made my task that much easier.

The North Bridge, shown in Daniell's view, was replaced by the modern structure in 1894-97; the large building at the left-hand end was replaced by the General Post Office in 1861-66. The Scott monument, on the left, was erected in 1846 at the same time as the National Gallery, behind which lies Waverley Station where there has been a station since 1844. The square tower in the centre of my view is that of New College, originally built in 1850 for the Free Church of Scotland.

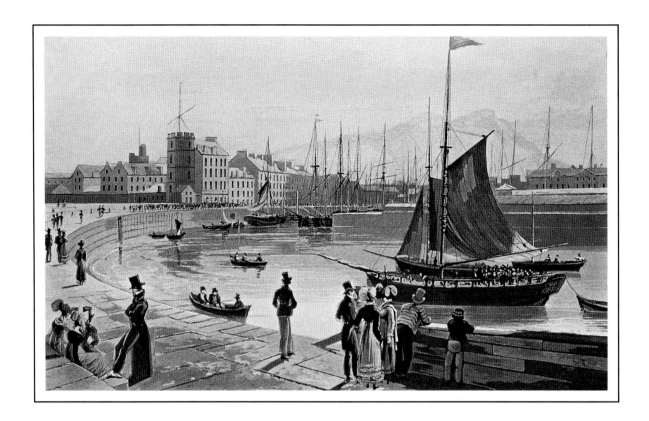

53 LEITH

The old streets of Leith, like those of most sea-faring places of ancient date, are narrow and dirty; but the modern ones, in point of regularity and elegance, are little inferior to those of the capital itself. The harbour is formed by a stone pier, and the town, consisting of two divisions, called North and South Leith, is united by a draw-bridge, over the stream called the water of Leith. The present view represents a part of the pier, and some of the buildings of the town near its commencement, the endmost of which is the Britannia Inn.

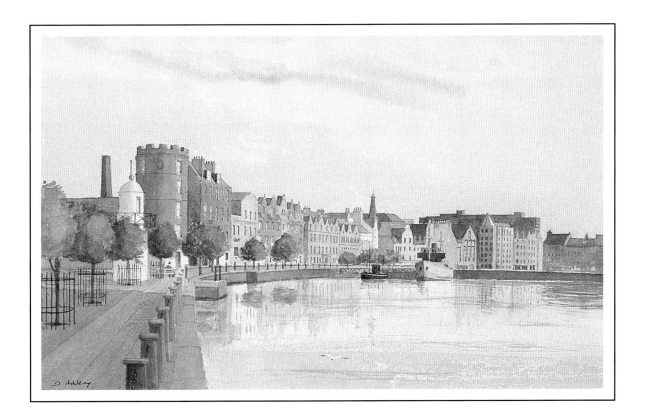

53 LEITH

It was a pleasant surprise to find this scene almost the same, although there is not the activity that was apparent in Daniell's day. There are only two boats moored here now, the smaller one used by a firm of architects and the other, the *Edinburgh*, a former restaurant which, at the time of my visit, was up for sale.

The round tower is the Signal Tower, built in 1686 as a windmill for grinding rape-seed. It is now part of the Malmaison Hotel. A wooden pier existed here as early as 1544, and in the early 17th century a wharf was added on its east side. About 1730 a 300-ft (91m) extension was built, and there was a further extension in 1826-30. The lighthouse, now defunct, dates from the time of the 1730 extension, although it does not appear in Daniell's view.

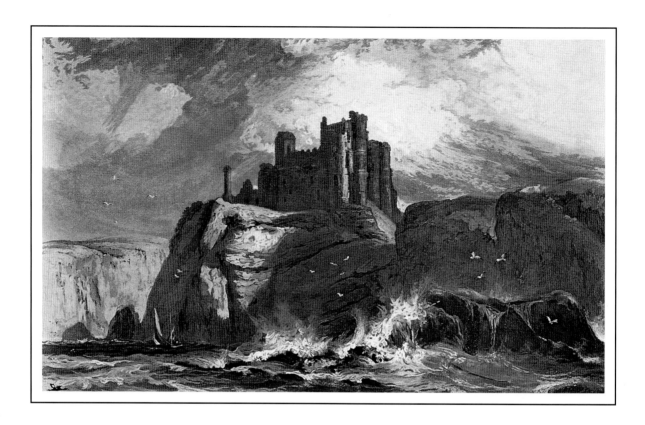

54 TANTALLON CASTLE

The castle is seated on a high rock projecting into the German Ocean. The circuit is of large extent, fenced on three sides by the precipice which overhangs the sea, and on the fourth by a double ditch and very strong outworks. Few readers can forget the description given in Marmion of this strong-hold in its 'high estate' of baronial magnificence:

'Tantallon's dizzy steep
Hung o'er the margin of the deep;
Many a rude tower and rampart there
Repell'd the insult of the air,
Which when the tempest vex'd the sky
Half breeze, half spray, came whistling by.'

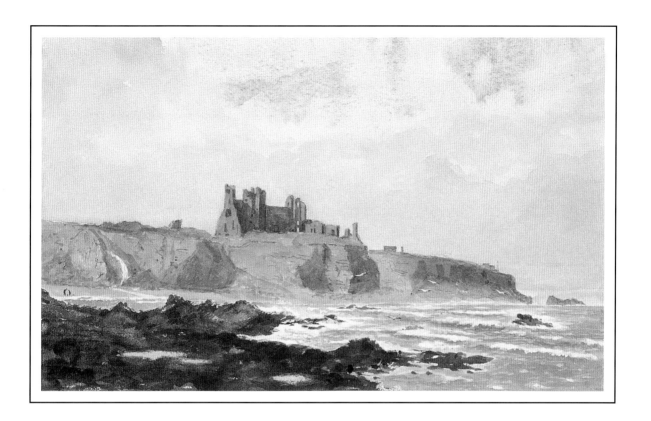

54 TANTALLON CASTLE

Built by the Douglas family in the 14th century, the castle, which features in Walter Scott's *Marmion*, was largely destroyed by Cromwell in 1651. Because I had spent too much time wandering round the ruins, I had missed the low tide that was needed to find Daniell's viewpoint from the north. I decided, instead, to take the view from the opposite angle, which is approached along a private drive and across a pleasant foreshore. It was only through the helpful guidance of the Historic Scotland staff at the castle that I found this place.

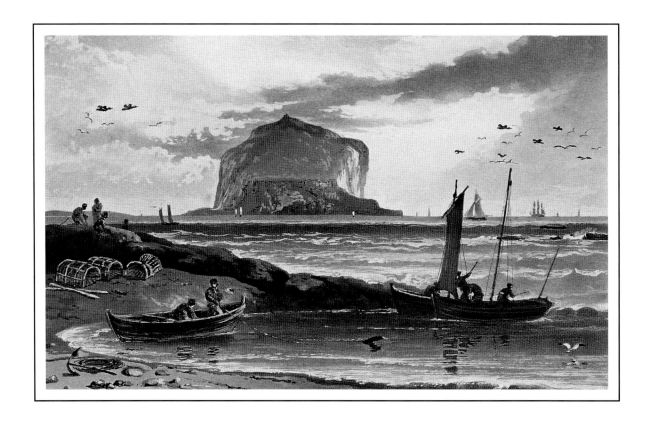

55 THE BASS ROCK

The rock was formerly appropriated to the reception and confinement of prisoners, but has for some years been uninhabited. Having procured a boat, an excursion was made for the purpose of observing the numerous flocks of waterfowl, which inhabit its precipitous sides; the multitude of these birds appeared truly astonishing. It is a remarkable fact, that the Solan geese, which breed here is such numbers, are found on no other part of the east coast, nor indeed on any of the rocks or islets in the vicinity of Scotland, except Ailsa Craig and St Kilda.

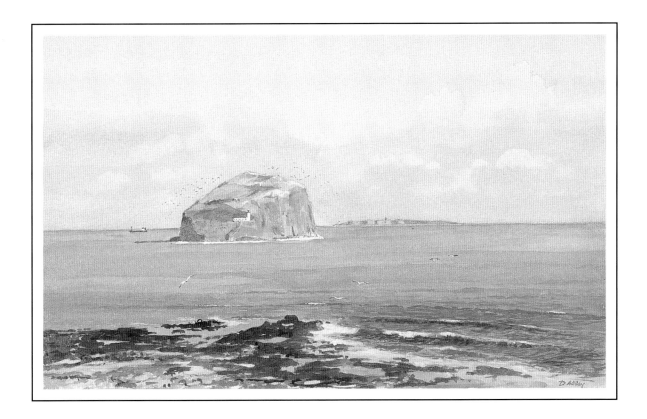

55 BASS ROCK

This 350-ft (106m) high, fascinating rock is still the home for thousands of gannets, *sula bassana*, and I wonder how the lighthouse keepers tolerated their noise and smell. The lighthouse, established in 1902, was automated in 1988. In the 17th century, thirty-nine Covenanters were imprisoned here.

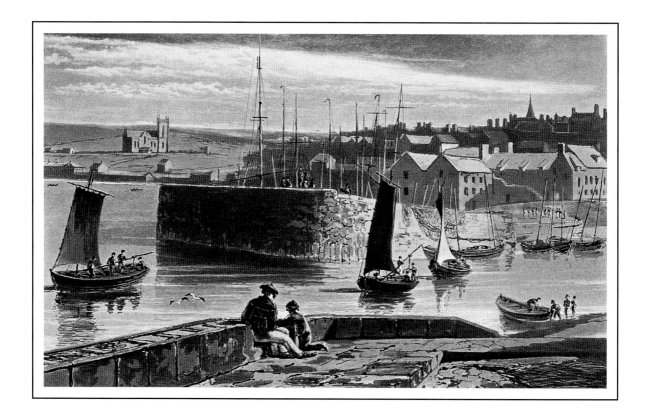

56 DUNBAR

The town is considered healthy, and is occasionally frequented by sea-bathers. The east pier of the present harbour was begun in the time of the commonwealth, and Cromwell granted £300 towards assisting the work. Early in the last century, it was enlarged and deepened, and about twenty years ago a new pier was constructed on the west side of the entrance. The sea in bad weather makes a complete breach over it. The small harbour, though very safe, is difficult of access, and is defended by a battery of twelve guns.

The church is an ancient structure founded in 1392. In the churchyard two grave-stones have been noticed, the date of one 1350 and that of the other 1351, from which circumstance, it may be inferred that the present edifice was founded on the site of a former church.

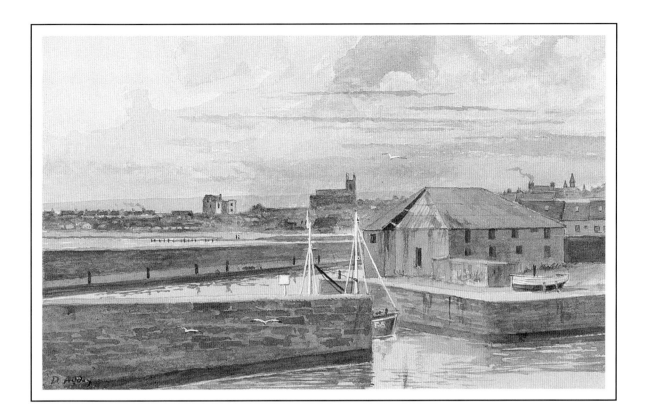

56 DUNBAR

A sad scene on a particularly depressing evening, and although there are some pleasant buildings along one side of the harbour there is not now much of merit in the chosen view. Only Dunbar Parish Church in the distance remains from Daniell's time and even the large building on the left of my view is in a ruinous state. Formerly a hotel, it was gutted by fire in the 1970s just after it had been scheduled of Architectural Interest, thus seriously affecting the cost of reconstruction, and rendering its future uncertain. The harbour entrance shown in Daniell's view has been blocked up.

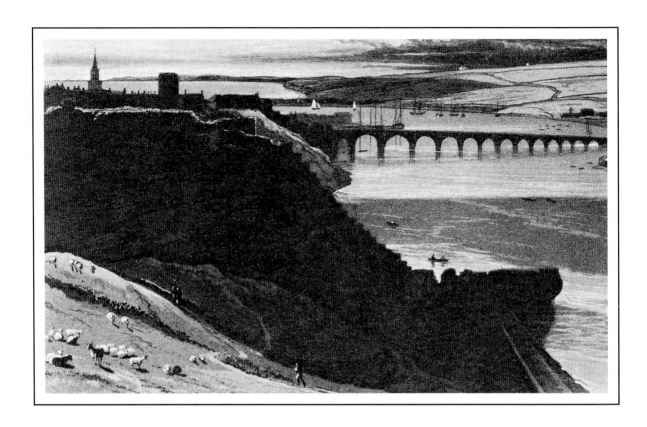

57 BERWICK-UPON-TWEED

Berwick has a market on Fridays, which is extremely well supplied; and a fair on the Friday in Trinity week, for black cattle and horses. Corn and eggs are shipped from hence to London, and other ports; but the principle trade is the salmon, caught in the Tweed, and esteemed equal in flavour to any in the kingdom; some are exported alive, and others pickled in kits, by persons who subsist by that employment, and are called salmon-coopers. At the time of this visit a pier of a very extensive nature was in progress, which when finished will give good shelter to vessels.

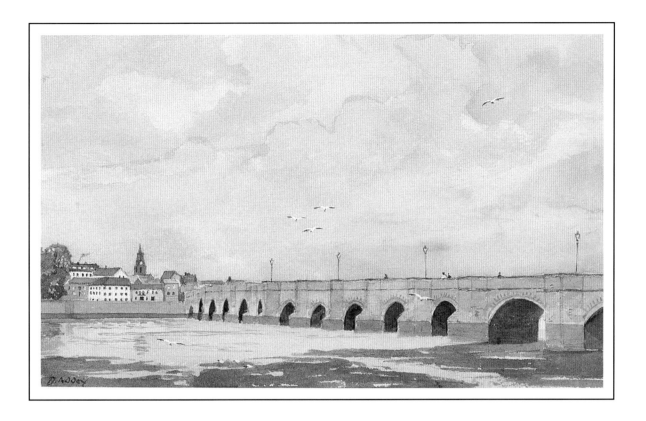

57 BERWICK-UPON-TWEED

Daniell's view of this delightful 15-arch Jacobean bridge is from under the Royal Tweed road bridge, built in 1925-1928, which carries the A1. I decided not to do this view as the buildings on the south side of the river lacked sufficient interest, whereas there was at least the church spire, shown in Daniell's view, on the north side. But this was not the only reason. A few days earlier I had been suffering from laryngitis, and, as I had not fully recovered, I did not want to risk further complications by sitting outside yet again, in the cold and wind, so I chose a viewpoint from the comparative comfort of the car. Rarely has it been necessary to go against the purpose of my project, but this time I felt justified.

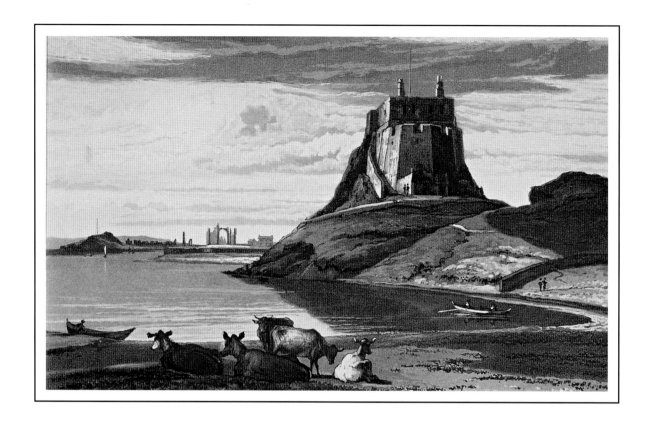

58 CASTLE ON HOLY ISLAND

The castle, which stands on a whinstone rock at the south-east corner of Holy Island, is a very picturesque feature; and the little bay to the northward of it was well covered with boats, waiting the arrival of the herrings.

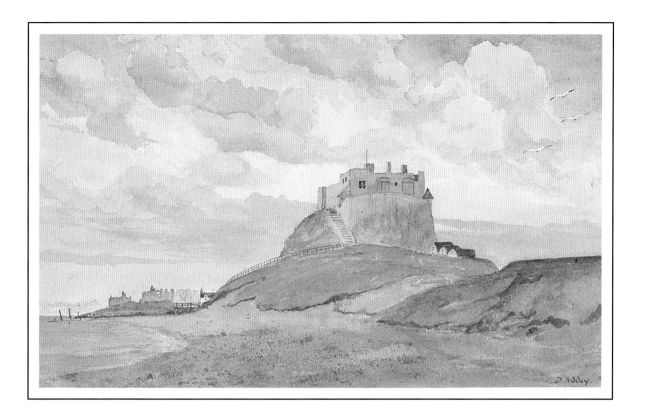

58 LINDISFARNE

This view is from the most extreme eastern tip of Holy Island, near the lime kilns. The castle, which dates from 1548, was extensively rebuilt in 1903-4 to designs by Sir Edwin Lutyens, who was architect to the owner, Edward Hudson, founder of *Country Life*. The walled garden by Gertrude Jekyll lies outside, a quarter of a mile to the north. On the right-hand side of the castle in my view there are three upturned boats, which form storehouses. The ruins of the Norman Priory church can be seen in the background.

The name of Lindisfarne derives from *farne* or land in the ancient Celtic tongue, and *lindis* or stream.

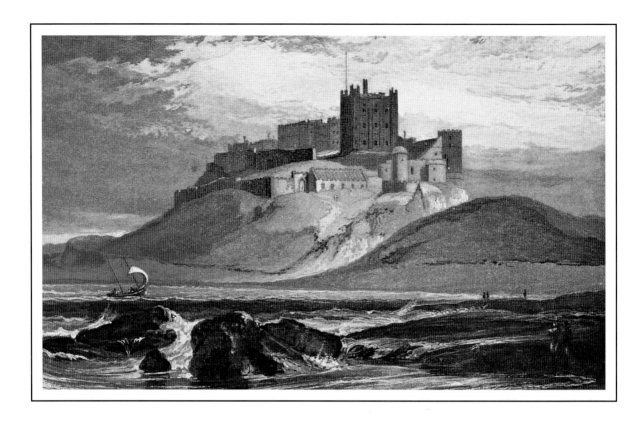

59 BAMBOROUGH CASTLE

This most imposing and magnificent-looking pile stands upon a basalt rock, of a triangular shape, high, rugged, and abrupt on the land side. Flanked by the sea, and strong natural ramparts of sand, matted together with sea-rushes on the east, it is accessible to an enemy only on the south-east, which is guarded by a deep dry ditch, and a series of towers in the wall on each side of the gateway. As this rock is the only one on this part of the coast, the site of the fortress is still more conspicuous. Its surface is beautifully besprinkled with lichens of various rich tints.

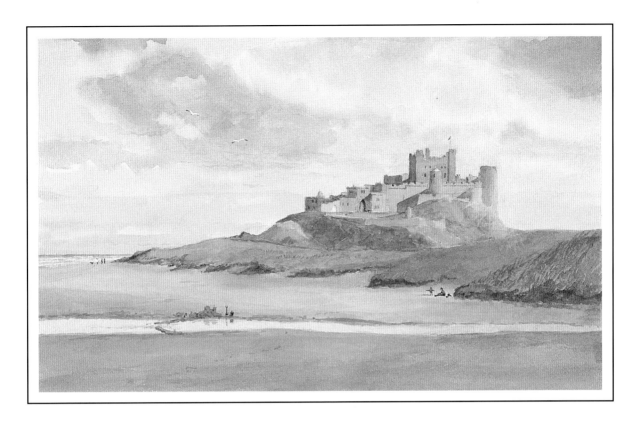

59 BAMBURGH CASTLE

This must be one of the most popular subjects on the east coast, where there has been little change since Daniell's visit. He comments that; 'considered as a picturesque feature of the coast, it is to be observed that the shore, being very sandy, detracts in some degree from the imposing effect which it would otherwise have; in this respect it will not bear comparison with the castle at Tantallon'. For me and, I believe, for most artists, it is the splendid sweep of sand, of reflections in pools of water and the expansive sky that give this scene its particular appeal.

You will see that there is a 'mighty sand work' in the image of the castle, which its creator is trying to persuade a parent to come and admire. This reminded me of my younger days when I would build massive dams and sea defences using the largest garden spade I could find.

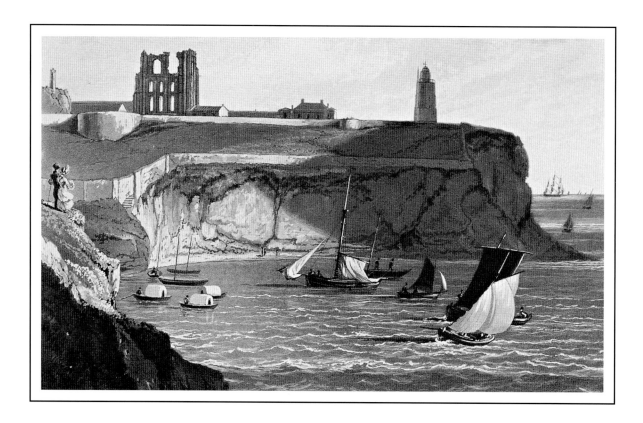

60 TYNEMOUTH

Tynemouth presented a scene of great activity, from the constant arrival and departure of vessels of different descriptions and sizes. The principal antiquities are the Priory and the Castle, of which the situation is commanding, but their appearance is greatly injured by the obtrusion of modern buildings. There is a very convenient little cove for bathing, and it is provided with plenty of machines. Here are also hot baths. The cove is called the Friar's Haven.

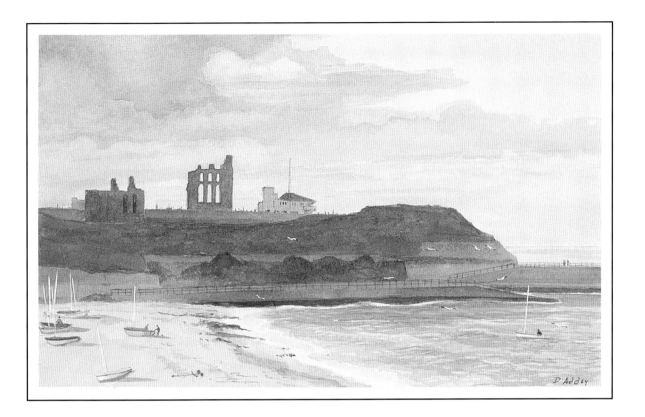

60 TYNEMOUTH

Basically, the scene remains very much the same as at the time of Daniell's visit in 1821, although one 'storey' of the priory has disappeared as, also, has the lighthouse, which was built about 1776, and ceased to function in 1898. The modern building to the right of the Priory is the coastguard station opened in 1983. Construction of the North Pier was begun in 1854 and completed in 1909.

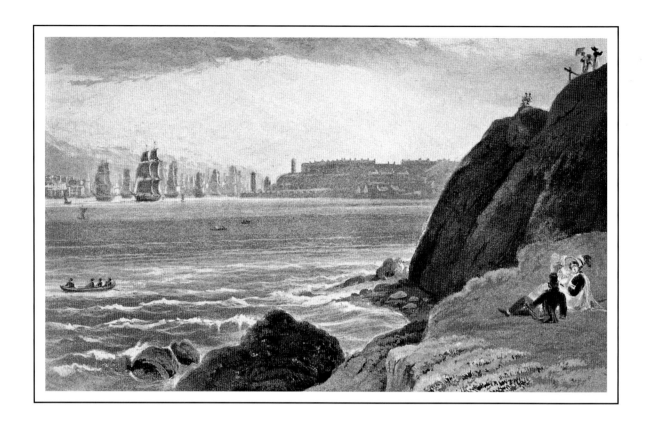

61 NORTH SHIELDS

The most fashionable part of the town is Dockwray Square, chiefly inhabited by wealthy ship-owners. Among the improvements may be noticed an elegant inn, built by the Duke of Northumberland; a new market-place, on the side of the river; and a public library. At the foot of the town are two light-houses, maintained by the Trinity House of Newcastle; and near them is Clifford's Fort, built in 1672, which effectually commands all vessels entering the river.

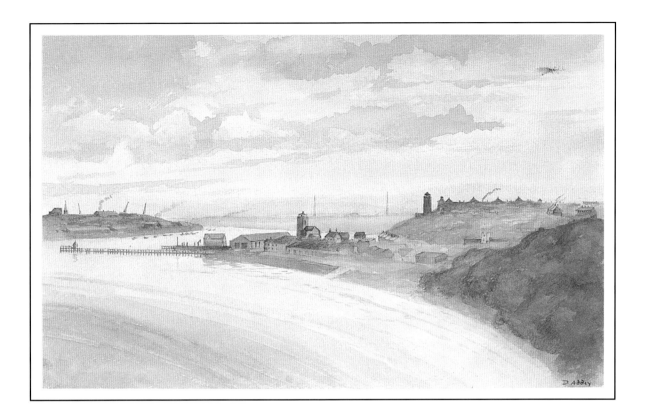

61 NORTH SHIELDS

This subject really did present a challenge and is taken from the top of the cliff shown on the right-hand side of Daniell's view. It is a highly industrialised scene but, despite all the development, the two large square lighthouses shown by Daniell on the distant headland still exist. These were not so much lighthouses as guide lights, and were erected in 1808; incoming ships would take a bearing off the two beams of light to find the safe channel into the mouth of the river.

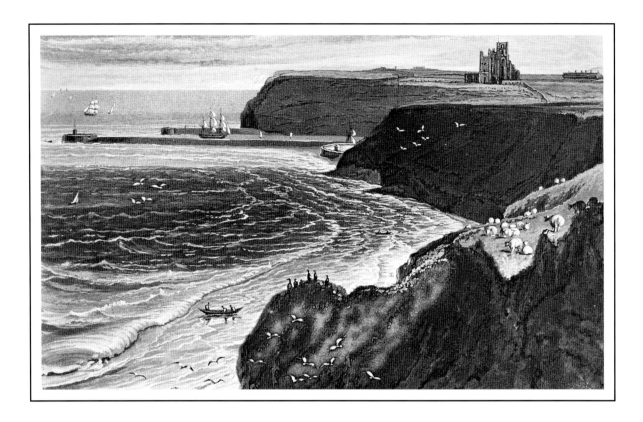

62 WHITBY

The alum-works of Lord Dundas, in the neighbourhood, have contributed largely to increase in trade of the town. Its streets are closely and irregularly built; but the houses of many of the opulent inhabitants are spacious and elegant, though incommodiously situated. The parish church is near the top of the hill, on the eastern side of the town, and is approached from the bottom of the vale by an ascent of one hundred and ninety stone steps.

The western pier makes a beautiful appearance, being regularly built of squared stone, extending nearly 520 yards, and terminated with a circular head. One of the other piers stretches out from the eastern cliff, and contracts the entrance to the harbour, which is very difficult of access in stormy weather.

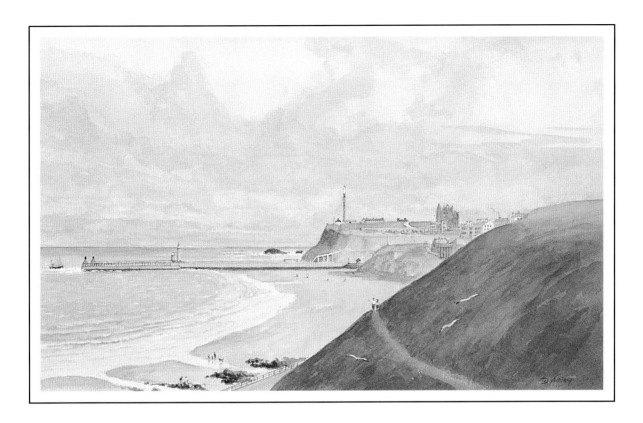

62 WHITBY

I was concerned about the prominent foreground to this view but if I had gone farther to the left I would have fallen over the cliff edge, and if I had moved to the right I could not have seen the abbey.

My accommodation for two nights was in a pleasant bed and breakfast on the sea-front. However, it had one shortcoming, which I found rather surprising. With my morning cup of tea I had used up the small supply of packets of sugar. When I returned in the evening I found that they had not been replaced, and so I went in search of someone to ask for more. Nobody was anywhere to be seen, but I found a tray in the hall on which there were tea bags, coffee bags and packets of sugar – all priced at 5p each.

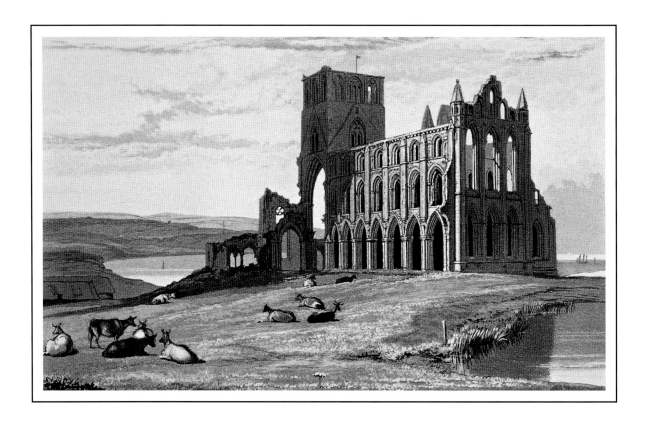

63 WHITBY ABBEY

The ruins of the abbey, from their elevated site, have an imposing appearance when seen from a distance, which becomes less so on a nearer approach, when the effect is somewhat injured by the proximity of the church, which stands to the westward. The eminence on which they are situated is steep towards the town, but declines very gently towards the south-west. It appears to be about eighty yards above the level of the sea, and commands a picturesque view of the town, the river Eske, and a tract of cultivated country bounded by high black moorland.

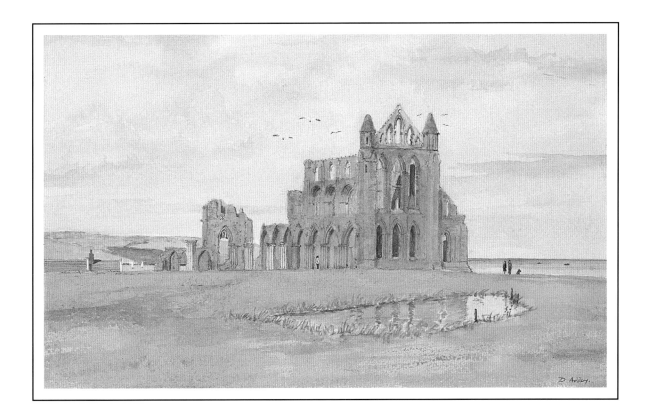

63 WHITBY ABBEY

The abbey was the final scene to be depicted on this stage of the Voyage. The tower, shown in Daniell's view, has collapsed and only four lower and three centre and upper bays remain of the south elevation. The east elevation is largely unchanged and the pond still exists, although rather overgrown.

I had made an early start on a cold and windy day, but it was not long before a continuous stream of sightseers was passing by on their way from the car park to the ruins and back again. Most of them kept at a discreet distance, but one young man persisted in standing behind me for some time. This can be extremely irritating, but I have heard of an eminent artist who found a way to solve this problem by placing a cap on the ground in front of him containing several coins.

The eighth stage of my Voyage was completed here on 29th September 2000.

64 SCARBOROUGH

The form of this bay is semicircular, and the town rises finely from its concave slope in the form of an amphitheatre. The principal streets in the upper part are spacious and well paved, and the houses have in general a handsome appearance. The new buildings on the cliff are considered almost unrivalled in respect to situation, having in front a beautiful terrace elevated near a hundred feet above the level of the sands, and commanding a variety of delightful prospects.

The harbour is easy of access, and has sufficient depth of water at full tide to admit ships of large burden. The piers seem to date their origin from the reign of Henry the Second, and to have received various additions and improvements in subsequent reigns.

64 SCARBOROUGH

The ninth and final stage of the Voyage began here in April 2002.

The large building, known as Mr Wood's house, on the left of Daniell's view, was replaced by the Grand Hotel in 1867, which is now owned by the Butlin organisation. While I did not stay in this hotel, had I done so I could have slept in a different room for each night of the year, swept 52 chimneys, strolled round 12 floors or climbed 4 turrets. Daniell shows people and carts on the Bridlington Road and although this still exists, the main road is carried over the valley on a fine viaduct built in 1863. The Spa Bridge for pedestrians, that strides across today's scene, dates from 1827. The Rotunda Museum, on the left, was built in 1829.

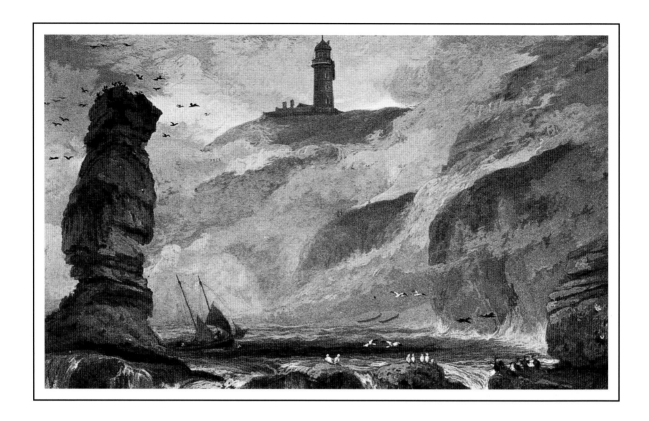

65 LIGHT-HOUSE ON FLAMBRO'-HEAD

An opportunity was here afforded of exhibiting the effect of one of those sea mists or fogs, so prevalent on this coast, which, while they involve all below in dense obscurity, afford partial glimpses of the more elevated objects, and cause them to resemble some visionary creation in the clouds.

The present lighthouse was built by order of the brethren of Trinity House, and was first illumined on the first of December 1806. From the month of June 1770, down to that period, the number of ships lost or wrecked on the head amounted to one hundred and seventy-four; and so efficacious has this structure been in preventing similar calamities, that not one wreck has been known to happen when the lights could be seen.

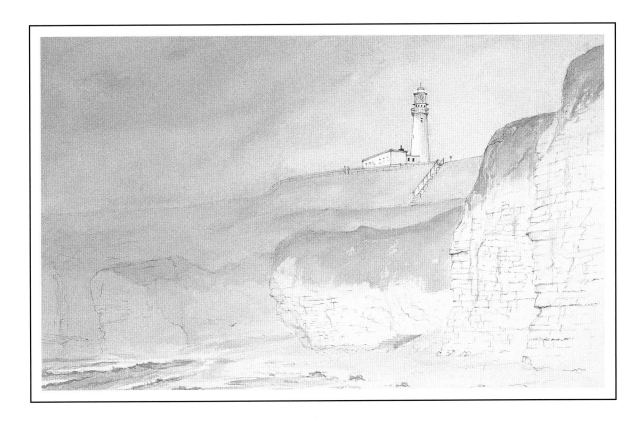

65 LIGHTHOUSE ON FLAMBOROUGH HEAD

When I first saw this lighthouse, the upper part was totally obscured by fog, even though I was standing at its base. Returning another day I was more fortunate – for a few moments. I had just finished drawing the view of the lighthouse from Selwicks Bay when dense fog rolled in again off the sea, and the subject completely disappeared for good; as you will see, the situation was just the same at the time of Daniell's visit. There is still a large, free-standing rock as depicted by him, but it is much closer to the cliffs.

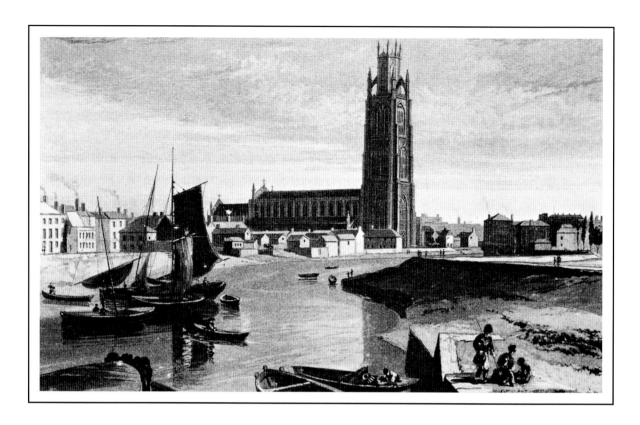

66 BOSTON

From Grimsby the whole line of the Lincolnshire coast presents merely a continued flat muddy bank, without one object of interest, or in any way picturesque, until, having entered the mouth of the river Witham, the voyager approaches Boston.

The chief object of curiosity and beauty in the town is the church, a large, elegant, and interesting pile of architecture, most simple in its form, and beautifully ornamented. Its tower which measures 282 feet in height, is said to have been built after the model of that belonging to the great church at Antwerp, and may be called the most elegant as well as the loftiest tower in England.

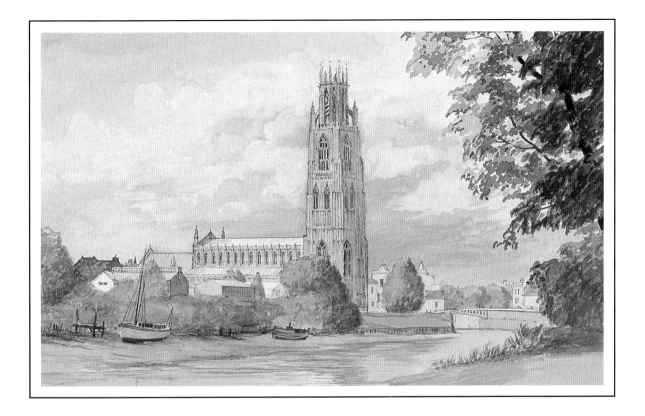

66 BOSTON

After travelling along the bleak, caravan-covered coast of Lincolnshire, I arrived at this pleasant town where the tower of St Botolph's Church, curiously named the Boston Stump, is like an exclamation mark in the flat fen landscape. At 272-ft (83m) high it appears to be slightly shorter than in Daniell's time – probably an error on his part.

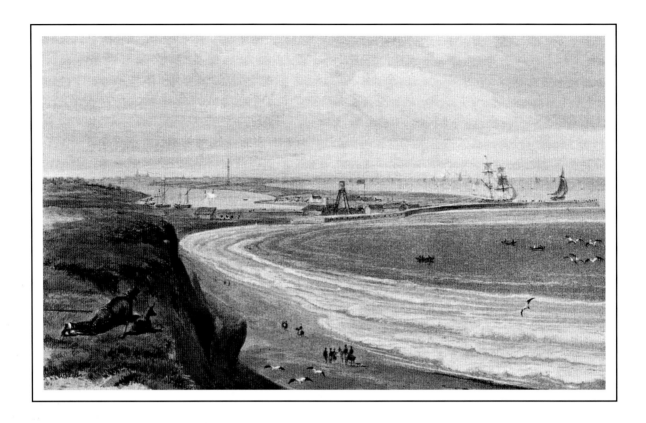

67 YARMOUTH

The present harbour was planned by Joas Johnson, a Dutchman, who was brought from Holland to supervise the work. The *Quay* is justly the pride and boast of the inhabitants, for it is allowed to be equal to that of Marseilles, and the finest and most extensive in Europe, except the far-famed one at Seville.

Yarmouth has long been frequented as a watering place; in 1759 the bathing-house was erected on the beach, and on each side of the vestibule is a bath, one appropriated to gentlemen and another to ladies. In the year 1788, a public room was added to the building, where public breakfasts are given twice a week during the season.

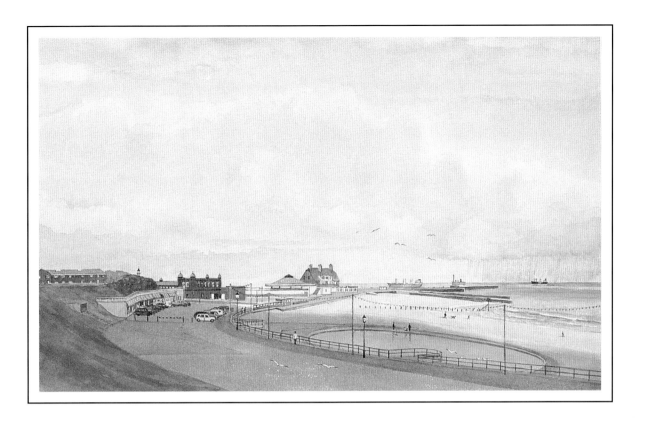

67 GORLESTON-ON-SEA, GREAT YARMOUTH

This view is from Gorleston-on-Sea and Daniell shows an interesting feature – a lookout tower in the centre of Gorleston pier. While there is some sign of development on the spit of land between the River Yare and the sea, the prominent object he has shown in the middle distance is Nelson's Pillar, erected in 1817; this still stands, although surrounded by modern dockside buildings. Very little of Great Yarmouth can now be seen from this viewpoint. The left-hand building on the pier is the Pavilion, opened in 1901. The Pier Hotel, dated 1897, stands on the right, while the Floral Hall, built in 1938, is in the centre.

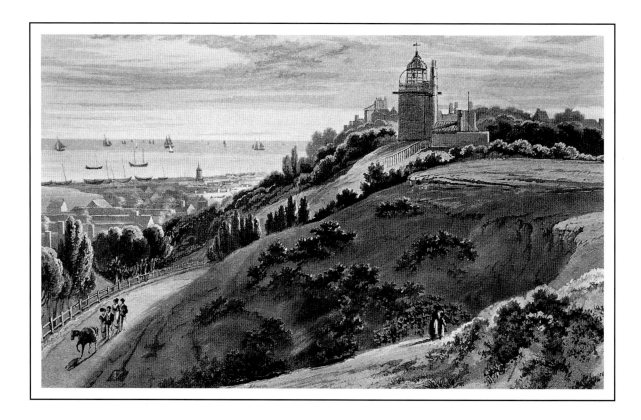

68 LOWESTOFF

The sands hereabouts are considered dangerous to mariners: hence Lowestoft is provided with two light-houses and a floating light. The upper lighthouse, a circular tower of brick and stone is situated on an elevated point near the edge of the cliff. The upper part was originally sashed, so that the coal fire, continually kept burning within, might be visible by night at sea. On the beach below the cliff, stands the lower lighthouse, which is of timber, hung in a frame of the same material, and so constructed as to be moveable.

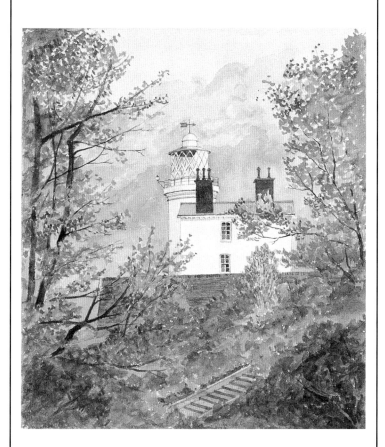

68 LOWESTOFT LIGHTHOUSE

Trees now totally obscure Daniell's viewpoint. Construction of the original lighthouse was carried out in 1676 under the stewardship of Samuel Pepys, whose coat of arms can still be seen along with those of Trinity House. A major re-build took place in 1874, when the light was altered from coal to light oil burning, with consequent changes to the lantern. The tower is on its original site, and became know as the Highlight. The Lower Light, shown in Daniell's view, was extinguished in 1923, and the land on which it stood is now covered by extensive industrial development.

Daniell spelt Lowestoft incorrectly on his aquatint, although it is correct in his text. Examples of similar discrepancies occur at Findlater Castle and Inverbervie Bridge. This suggests that others might have prepared the borders and titles for the aquatints, perhaps misinterpreting his handwriting or mishearing his instructions.

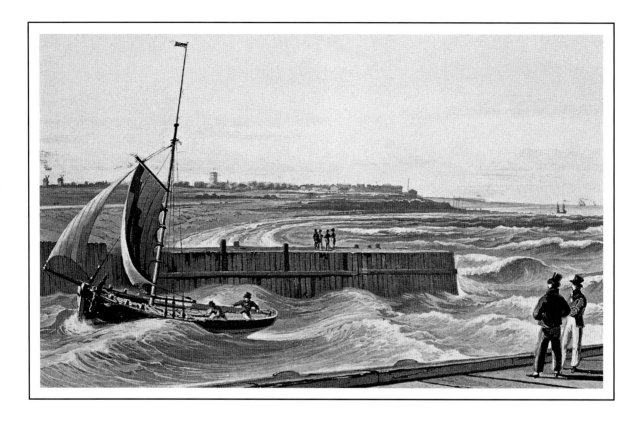

69 SOUTHWOLD

The town is pleasantly situated on an eminence overlooking the sea, but nearly surrounded on every other side by the river Blyth, which here terminates its course.

The most conspicuous object here is the chapel or church, which was erected about 1460 on the site of a former edifice. The tower steeple, about one hundred feet in height, is a fine piece of architecture, beautified with freestone, intermixed with flint of various colours. The exterior of the structure is richly ornamented, and in the interior there are the remains of decorations still more curious and elaborate. The only other public building of note is the guildhall.

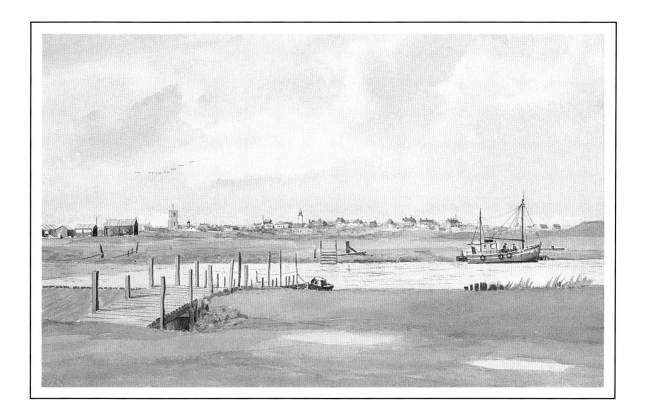

69 SOUTHWOLD

Not surprisingly this is another favourite East Anglian haunt for artists with its soaring skies that tower over the flat landscape, and where Southwold is seen from the Walberswick side of the River Blyth. What is surprising is that some of the coast appears to have been regained from the sea, and there is now more housing and a caravan park to the right of Daniell's view. Perhaps it is fortunate that the sea is receding as a beach hut sold recently for £30,000.

Both the 15th century St Edmund's Church and the lighthouse, built in 1887, rise to a height of 100-ft (30m) over the town.

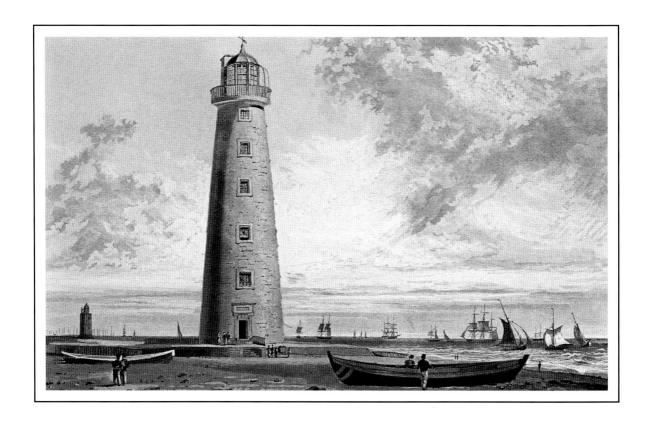

70 THE ORFORD NESS LIGHT HOUSES

This lighthouse, as well as its neighbour, the Low Light, about a mile distant, is the property of Lord Braybrooke. It is kept in delightfully clean order by its occupants who on this barren shingly beach have contrived by great industry to form admirable little flower and kitchen gardens. The height of this larger lighthouse is about one hundred feet. Near it, on the beach, is a boat, called the sailor's friend, ready to be launched at a moment's notice on any emergency. There is also a revenue cutter boat, which may be sent to sea with the same promptitude.

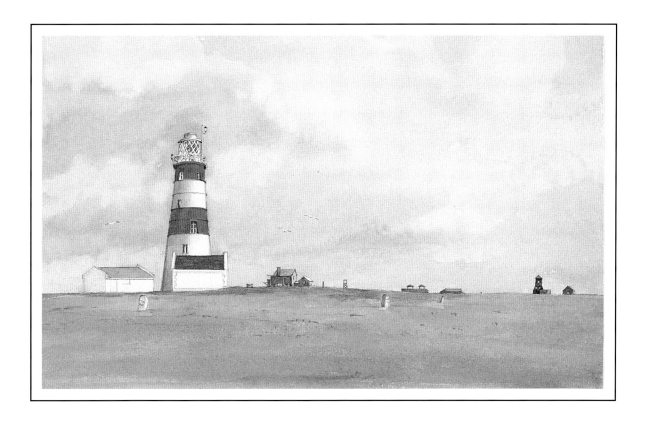

70 ORFORD NESS LIGHTHOUSE

For many years Orford Ness was used by the Ministry of Defence for experimental purposes, and access to it was strictly forbidden. No longer required by the Ministry, it is now in the careful hands of The National Trust. I was fortunate to arrive, by chance, on a Saturday, which is the only day on which a ferry runs out of season. It takes an hour to walk from the landing stage to the lighthouse, and I sensed the threat of rain. Unfortunately, no sooner had I sat down to start my drawing than it began to drizzle. Fellow ferry folk, all properly dressed in waterproofs, probably chuckled at my umbrella, but how pleased I was that I had it with me.

Daniell's view is looking north where he has shown the Lower Light. This was abandoned in 1887 after a severe storm. My view is taken in the opposite direction and includes some of the Ministry's derelict buildings.

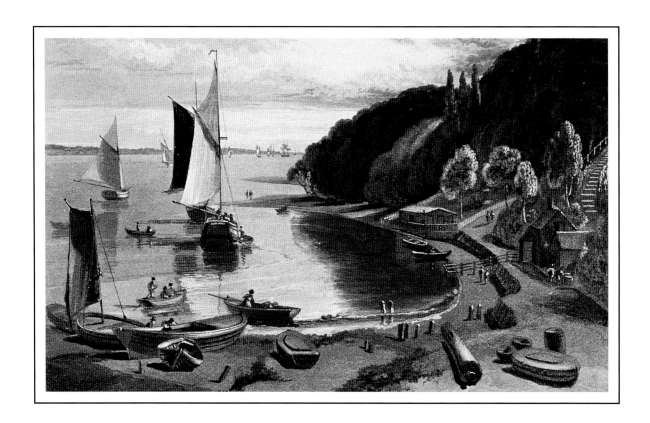

71 MISTLEY NEAR HARWICH

Though not strictly a coast feature, a view is here introduced, in the confidence that such a scene, as it includes a sea prospect, will be favourably received, for the sake of compensating for the scarcity of interesting objects on the shore of Essex.

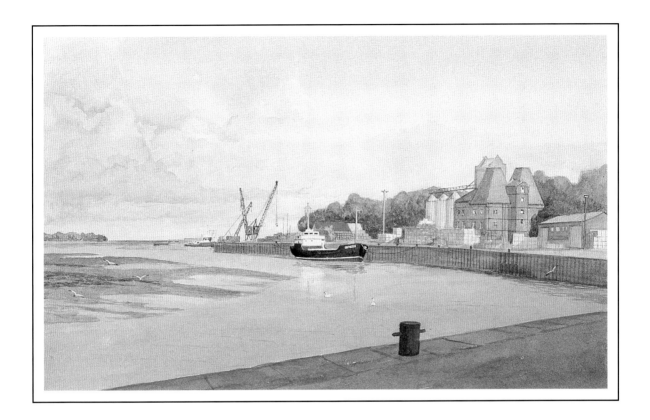

71 MISTLEY

If we look at the map of Lincolnshire and East Anglia, we will see how few subjects Daniell found along this part of the coast. It was not that he was tiring or coming to the end of his circumnavigation, as he still had to travel along the whole of the south coast. Perhaps he found the low-lying country uninspiring or was disappointed by the noticeable lack of cliffs and castles. The view of Mistley is introduced, he says, to compensate for the scarcity of material on the Essex coast, but he also received a very hospitable reception at a house of a gentleman in the town.

Only two kilns remain of the Maltings that were built in the late 19th century, while the adjoining granaries and warehouses are being converted into flats. The busy, small harbour is now used for the import of granite, timber, salt, and anything the larger ports will not handle.

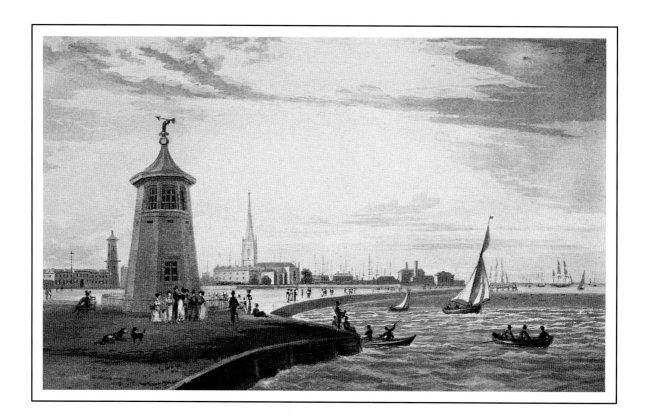

72 HARWICH

The town consists of three principal streets, and various lanes, branching off in different directions. It was formerly surrounded by walls, and had several gates, which are now demolished: here was also a castle, and several small forts or blockhouses, which are entirely destroyed; the sites of the latter are covered by the sea, which is slowly but continually encroaching on the land. The entrance to the harbour is now so narrow as scarcely to afford working room for large ships, few of which venture into it. There are two lighthouses for the safe guidance of vessels on entering.

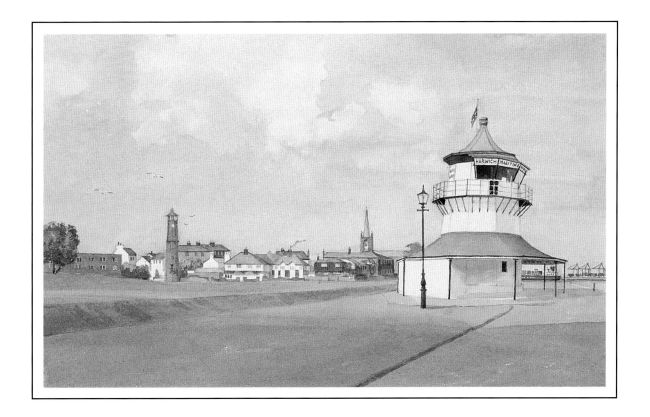

72 HARWICH

It was pleasing to find these two lights, both built in 1817, still standing, although no longer in use. They were replaced in 1863 by two lighthouses at Dovercourt. The Lower Light, with its 'umbrella' shelter that was added later in the 19th century, is now a small but excellent maritime museum. The High Light was designed by John Rennie.

An interesting and unique feature that is obscured by the Lower Light is the tread-wheel crane. Built in 1667 it was re-erected on Harwich Green in 1930. It had no effective braking system and on one occasion a young lad was inadvertently left alone inside, but he did not have sufficient strength to stop the wheels revolving. Consequently he was whirled round and round, and when the wheels were eventually stopped the poor lad was found to be unconscious.

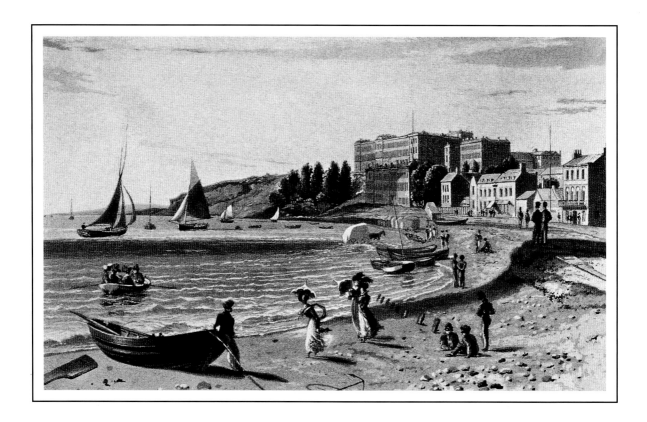

73 SOUTH END

This village is pleasantly situated on the acclivity of a hill, agreeably sprinkled with wood, nearly opposite to Sheerness. For many years past it has been in considerable repute as a bathing-place, and has a range of very acceptable lodging houses, with an assembly-room and other means of amusement suited to a sea-side residence. The prospect from the cliff to the west of the town is particularly agreeable. On the whole, South End may be considered as an agreeable summer residence; and considering the low, dull, uninteresting coast, which leads to it from the open sea, it presented a more pleasing close to this excursion than had been anticipated.

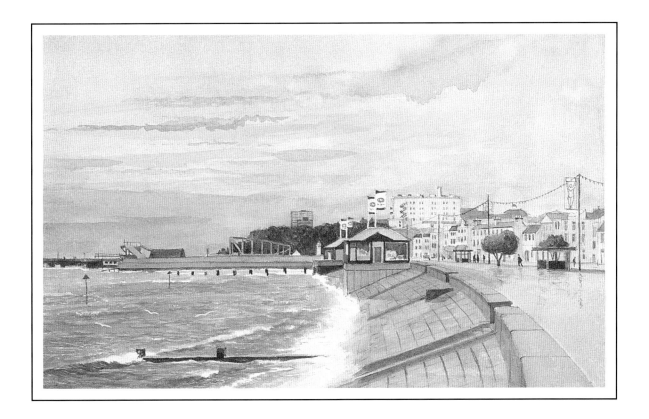

73 SOUTHEND-ON-SEA

Wet, windy weather greeted me when I arrived at my final destination. Across the Thames Estuary I could just see the north coast of Kent from where I had set out on my Voyage 14 years earlier. The scene here was not quite the disaster I had expected, and the trees, mentioned by Daniell as just a 'sprinkling', are now well established. The most prominent building in his view was originally the Grand Terrace and Hotel which, with Grove Terrace on the opposite side of the High Street, was built in the early 1790s as part of a scheme for 'New South End'. The terrace still exists as private residences called Royal Terrace. The large white building in my view was erected about 1900 as the Palace Hotel, but this closed in the 1970s. To ease the surge of trippers to the area, Marine Parade was widened in the first decade of the 20th century.

After completing my drawing, I had my last cup of tea in a promenade café amidst buckets and spades, colourful hats, Union flags, gaudy postcards, and all the other trappings of a seaside resort. Inevitably it was a time for quiet reflection, and to recall some of the places I had visited, the friends I had made and the overwhelming interest and support that I had received throughout the Voyage from so many people. It was, though, to the remarkable journey made by William Daniell between 1813 and 1823 that I turned my final thoughts and admiration – and then contemplated what to do next.

THE END

EPILOGUE

Time flies! In the course of our gallery's regular events through the years the seasons come and go, time slips through our fingers and we are surprised at our age.

In the preface to David Addey's first volume of his *Voyage* I started by mentioning that I had known him for nearly a quarter of a century. With this, the epilogue, our friendship will have been of thirty-two years' duration. However, if this produces some sensations of the speed of passing time, these are changed when we ponder on David's *Voyage Round Great Britain*. The project took fourteen years to complete and, tragically, during the third year it became clear that the artist's beloved wife and companion for thirty-four years would not for much longer be at his side. A poignant reference to this (below the first plate of Volume Two) is not easily forgotten. David pressed on alone to complete his project. We are, perhaps, made to realise that we can never take for granted our situation in life any more than we can the precious landscape he has depicted in these four small volumes.

Daniell's purpose was to bring before the eyes of the British public their own coastal landscape that was largely unknown to them. Nearly two hundred years later David Addey, in following in Daniell's footsteps, has provided the comparison. Historically this will prove to be an equally important record, and if our artist did not suffer the same hardships on the road, as did Daniell, his was still an epic journey of which these volumes and his watercolours will be a permanent memorial. This is an achievement of which he can feel justifiably proud.

Martyn Gregory
July 2002

THE BED AND BREAKFAST

'We found that one of the cottages was a public house, with no promise on the outside, but furnished with plenty within, and a very sensible landlady, who maintained that nothing was superior to a good breakfast, which she regarded as the foundation on which every thing useful or agreeable in the business of the day was to be raised. We were precisely in a state to coincide with her in opinion, and to admit, that no circumstances, however elevated, can make us forget, for any length of time, that we have a stomach. Love and jealousy may have great control over us, but in the long run we are slaves to nothing so much as bread and butter'

Richard Ayton

When William Daniell and his companion, Richard Ayton, set off from Land's End in 1813 they had only a vague idea of what they would see on their Voyage Round Great Britain. They will have had letters of introduction to various landowners, suggestions of some suitable places to visit, and where they might find accommodation. In his Introduction to the Voyage, Ayton comments that *'the coast has been unaccountably neglected and, if we except a few fashionable watering-places, it is entirely unknown to the public'*. How different today when almost every nook and cranny is well documented and explored, with access by sea or land so much quicker and easier. It was within a few days of starting on their epic journey that our intrepid explorers found themselves in the public house at Combe Martin where the *'very sensible landlady'* undoubtedly set the standard of breakfasts that are now expected throughout the British Isles.

However, they were not so lucky at Porlock where *'there were two beds in one room at the public house in the village, which we were determined to occupy for the night. As we were retiring to them, an embassy arrived from the tap-room, representing to us that the boatmen could procure no beds for themselves, and that it was their particular desire that we should content ourselves with one bed, while they four resigned themselves to the other – and all this in a room ten feet long and a bed's length wide. Such an arrangement had been sufficiently odious at any time, but in July – Spirits of Lavender defend us!'* We can just imagine what *'an embassy from the tap-room'* would be like late at night.

Many beds have been slept in and countless breakfasts have been eaten since then. On this Voyage my contribution totals seventy-seven, apart from nights spent by invitation in private houses. Nowadays, of course, if a B&B is recognised by a Tourist Board, grading and classification are of paramount importance.

The English Tourism Council produces a 120-page document called *The Pink Booklet*, which covers a vast number of rules and regulations. In addition there are guide-books on Standards and Ratings Requirements, which tend to make the basic characteristics of B&Bs almost identical in England, Wales and Scotland. How frightening to think that for the rest of time such B&Bs might always be the same. Conformity is the password for being a *Listed* B&B. All crockery and cutlery must match, there must be the same packets of biscuits, coffee, tea and sugar, milk is to be UHT in tedious little cartons (even in Devon!), candlewick bedspreads are forbidden, a television set is an absolute priority, decorative wallpapers are preferred to painted walls ……. the list goes on and on. Certainly, *Listing* would have weeded out the one or two places where standards left much to be desired, but there were also many excellent B&Bs which were not *Listed*. I had one joyous experience when I was told that the fresh milk for my morning cup of tea would be on the table in the passage outside my bedroom. Sure enough, there it was, with a dainty coverlet to keep out the dust and flies.

Why did I not use a caravanette or something similar so that I could be entirely independent? This idea did not appeal to me at all and, anyway, enough time would be spent travelling in a vehicle while searching for the subjects. I decided not to book accommodation in advance as doing so could limit my movements. No, the best plan was to find Daniell's view and then search for a B&B as near as possible; this policy worked remarkably well. I did not want the project to be a hardship or too much of a race against time. It was important, also, to meet people on my way, and this aspect of the whole Voyage proved to be a great joy.

The lone, male traveller can be at a disadvantage. Often there are no single bedrooms, and it is usually necessary to pay a premium for a double room, which I think is rather unfair. I accept that couples may arrive after the single person has booked in, but if this does not happen then surely a single rate should apply. It was on the Outer Hebrides where I found a most refreshing answer to this problem. I arrived in the early afternoon at a pleasant house on the Isle of Harris. Yes, there was a vacancy but it was a double room, and there would be an extra £10.00 for the single occupancy. When I was presented with the bill the next morning I noted that the £10.00 had not been added. I queried this and was told that as no one else had sought accommodation after my arrival the additional £10.00 was waived.

In most cases a landlady greeted me, but there was one notable exception on the south coast near Bridport where a 'land-gentleman' was mine host. He met me at the door, showed me to my room while calling me 'dear' and 'love', and I never saw him again. It was even more curious in the morning when I went down for breakfast. Hot tea, toast, bacon and eggs were already on the table, and yet there was no sign of anyone. I waited and wandered around pondering what to do about paying, but in the end I gave up, put some money on the table with a note and departed. I did wonder afterwards if in fact it was a B&B, a private house or, indeed, if it had all been a dream.

There was one occasion when a deposit of £5.00 was demanded, and this was in St Ives. I'm not sure why, as I had left my belongings in the bedroom, but perhaps the landlady, who was certainly related to a species of dragon, had deduced that they were not worth that much, possibly as I had announced myself

as being an artist. Surprising, particularly in St Ives, but as I had no beard, smock or easel, she probably thought that I was a fraud. Towards the end of my Voyage, in Yorkshire, I was rather taken aback when asked to pay the full amount, £40.00, before I had even brought my bags into the room.

Richard Ayton makes only one reference to the cost of accommodation, and this was for a room in a boarding house at 9 pennies per night (an agricultural wage in the early 19th century was about eleven shillings a week – probably much less along the poorer west coast). My first B&B, which was in Southampton in 1988, cost me £10.00, and the last one of a similar standard at Mistley was £42.50. At a hotel in Leith in 2000, where there were no single rooms, I was asked £110.00, plus V.A.T, but excluding breakfast. I chose not to grace it with my presence, and eventually found a small hotel in the centre of Edinburgh where the double room cost £25.00 including breakfast – and it had a car park. I believe that the highest price I could have paid was £450.00 – for one night! – at a hotel on the west coast of Scotland. I did not have the temerity to ask what was included in that sum – I could only fantasize – and settled on one of my more usual B&Bs near by. These were the exceptions, and on the whole I found the charges reasonable. Of the seventy-seven B&Bs, thirteen were in hotels, and I tended to use these if there was no other alternative or if I had had poor accommodation on previous nights.

There is always a certain excitement in anticipation. Where will the next night be spent, who will I meet, will there be an evening meal? Daniell and Ayton would have been even more uncertain about the nature of their next abode. It was near Lancaster when Ayton writes that he had further tribulations. *'The landlady, a neat, tidy-looking woman, whom I should not have suspected of such atrocities, conducted me up stairs, and opening a door, held her candle immediately under my nose, to guide me safely through several narrow passages, with room only for the legs sideways, made by four beds, which formed a blockade before the one intended for myself. Four people, she informed me in cold blood, were to sleep in each of the four beds, but I was to have only one single partner; and there, sure enough, before my eyes, soundly sleeping and soundly snoring, lay my destined comrade'.* It was too much for him, and the landlady was eventually forced to offer him a chaff bed in a hole at the top of the house.

Room sizes varied greatly but the smallest I had was in Tenby where a room in the attic was just big enough to hold a double bed, and the only way to reach the basin and the wardrobe was to leap over it. In Plymouth I had a fearful night in a dubious public house where there were six other single beds in my room; it was like a dormitory. I had visions of *'an embassy arriving from the tap-room'* in the early hours of the morning but, to my immense relief, nothing happened. Breakfast, too, was rather depressing; this was the only place on all my travels where the plate of food made me feel ill. Clearly the landlady, who served us in her night attire, did not have the same attitude to breakfast as the good lady found by Daniell and Ayton at Combe Martin. Yes, a full English breakfast, with all the trimmings, certainly sets one up for the day, but as time and age progressed I found myself in need of less and less.

It was quite by chance that, while travelling on the Isle of Skye, I came across the Wolsey Lodge organisation, which I found most agreeable; here one is entertained more as a house-guest. The name Wolsey recalls Henry VIII's Lord Chancellor, Cardinal Wolsey who, when he toured the realm in the 16th century,

expected to receive generous hospitality at any suitable country house on his way. A Wolsey Lodge is a home, not a hotel, and as a guest in a private house you have privileges and also obligations. As well as enjoying the normal comforts of a private house, a particularly pleasant aspect is the evening dinner where you eat at the table with your hosts and other guests.

I spent one night in a small bed and breakfast in Caithness, together with a young Swiss couple who did not speak English, three workmen who were white-lining the road from Inverness to Thurso, and a policeman from Essex whose luggage had been stolen at Prestwick airport. An interesting evening was spent talking to the policeman who, it transpired, had also crashed his car and was clearly fed up with life, and particularly with his work in the Metropolitan Police. The house, where we all shared the same bathroom, was really far too small for us. I was eventually shown to a room in the attic – I had visions of a chaff bed in a hole in the roof – where I found old fur-covered tea bags in the teapot and thick, green mould in the milk jug.

A visit from the local tourist board would have probably improved matters.

Conversations were many and varied. One landlady, knowing of my interest in painting, arranged for me to sit at a table with another couple on a painting holiday. The introduction was not particularly successful, as there was total silence throughout the meal. On another occasion there was just one other male guest who asked me what I did. 'I'm a painter' I said. After a while he enquired, 'What paints do you use?' 'Winsor and Newton' I replied. 'Never heard of them. I always use Dulux Weathershield'. I decided not to pursue the matter any further. Inevitably most conversations gravitated to the Voyage and the interest shown by so many people has been very heartening.

Bed and Breakfasts are a British institution, and those of us who use them are greatly indebted to all those hosts and hostesses who allow us into their homes, hotels and inns and who make every effort to give us peace and comfort. A final look at the conditions that faced Daniell and Ayton will make us realise our good fortune.

'There was no sign of entertainment for man or horse, so we knocked on the door of a vile hovel, to enquire which was the inn, when a man came forward and told us we had no further to go, and begged us to walk in. We were obliged to sit in the common room of the family; but this we should not have complained of, had it been only decently clean, only so clean as not to be equally offensive to the nose as to the sight. The black bread we could have borne, but the filthiness of every thing was insufferable. The landlord and ourselves were the only persons who wore shoes while the women sat exposing their bare legs nearly up to their knees and paddled about with naked feet'. 'At an early hour we begged to be shewn to our beds and were conducted to a room of large dimensions that occupied the whole of the upper part of the house. In the dim light we could just perceive that it was crowded with lumber and had to grope our way to our beds through rows of wooden stools and spinning-wheels. I awoke in the night and found that every corner was alive and, on the return of light, discovered that the whole family had shared it with us. The landlord woke first, and with a prodigious yawn, which roused the whole room, jumped out of bed, followed by the women and children. It was not yet five o'clock; but we were well pleased with the opportunity of rising, and soon found ourselves out of doors, where we breathed the pure air of the morning, fresh from the sea, with peculiar satisfaction'.

..........................

What is a man,
If his chief good and market of his time
Be but to sleep and feed? A beast, no more,

Hamlet

COMPLETE LIST OF ALL WATERCOLOURS
AND DRAWINGS ON THE VOYAGE

Note: a. WD denotes the William Daniell view.
 b. numbers do not relate to those in the books
 c. Subjects are not necessarily in geographical order.

1	WD	Sheerness
2	WD	Reculver
3		Sheerness docks
4		Reculver – morning
5		Sheerness – morning
6		Margate
7	WD	Broadstairs
8	WD	Margate
9		Broadstairs – evening
10	WD	North Foreland lighthouse
11		Walmer
12	WD	Deal Castle
13		Clouds over Walmer
14		St Margaret's Bay
15	WD	Ramsgate
16	WD	Walmer Castle
17	WD	Dover Castle
18	WD	Dover from Shakespeare Cliff
19		Channel tunnel works
20	WD	Shakespeare Cliff
21	WD	Folkestone
22		Boats on Hythe beach
23		Channel tunnel dredger
24	WD	Hythe
25		Hythe – sunset
26	WD	Dungeness lighthouse
27		Dungeness power station
28	WD	Rye
29		Church Street, Rye
30		Rye – sunset
31	WD	Winchelsea
32		Winchelsea church
33	WD	Hastings from East Cliff
34	WD	Hastings from near the White Rock
35		Eastbourne
36	WD	Beachy Head
37		Boats at Dungeness
38	WD	Brighton – near Regency Square
38a	WD	Brighton
39		Sky study
40		Sky study
41		The Seven Sisters
42		Seaford
43	WD	Shoreham
44		Portslade power station
45	WD	Arundel, view from the Park
46	WD	Littlehampton
47	WD	Bognor
48		Regency Bognor
49		Pagham Harbour
50		H.M.S. *Warrior*, Portsmouth
51	WD	Portsmouth from Portsdown Hill
52		Portsmouth Harbour
53		Storm clouds over Dungeness
54		Eastbourne – sunset
55		H.M.S. *Cardiff*
56	WD	Brading
57		P.S Waverley off Shanklin
57a	WD	Shanklin Chine
58	WD	Freshwater Bay
59	WD	Ryde
60		Whippingham church
60a	WD	Norris Castle
61	WD	West Cowes

62	WD	The Needles
63	WD	St Catherine's Chapel, Abbotsbury
64	WD	Poole Harbour
65		Boats at Christchurch
66	WD	Christchurch
67		The Priory, Christchurch
68		RFA off Portland
69	WD	Swanage
70	WD	Lighthouse, Isle of Portland
71	WD	Weymouth
72	WD	Corfe Castle
73	WD	Lulworth Cove
74	WD	Bridport Harbour
75	WD	Lyme Regis from Charmouth
76	WD	Teignmouth
77		The Cobb, Lyme Regis
78		Corfe Castle and village
79	WD	Sidmouth
80		Sidmouth
81		Charmouth
82		Eype Mouth
83		Torbay
84		Durdle Door
85	WD	Exmouth
86		On the quayside, Exmouth
87	WD	Babbacombe
88	WD	Torquay
89	WD	Brixham
90	WD	Junction of the Dart with the sea
91	WD	Entrance to Dartmouth
92	WD	Near Kingswear on the Dart
93	WD	Kingswear
94		Dittisham
95		P.S.Kingswear Castle
96	WD	Salcombe
97	WD	Staddon Quay
98	WD	The Citadel, Plymouth
99	WD	The Hamoaze from Mt Edgcumbe
100	WD	Port Wrinkle
101	WD	Bovisand
102	WD	View from Mt Edgcumbe
103	WD	East Looe
104	WD	Fowey from Bodinnick
105	WD	Polperro
106		Lyme Regis – evening
107		Storm at Lyme Regis
108	WD	Fowey Castle
109	WD	Polkerris
110	WD	Mevagissey
111	WD	Gorran Haven
112		Portloe
113		Boats at Portloe
114		Boats at Portloe
115		Portloe
116		St Mawes Castle
117		Truro
118		On the Fal at King Harry Ferry
119	WD	Portloe
120		St Mawes – evening
121		Old station, West Bay, Bridport
122	WD	Falmouth
123	WD	The Lizard
124	WD	St Michael's Mount
125		St Michael's Mount after a storm
126		St Michael's Mount – evening
127		H.M.S. *Broadsword*
128	WD	Mullion Cove
129		Mullion Cove
130	WD	Penzance
131	WD	Land's End
132		Old traction engine
133		Fowey from Bodinnick
134	WD	Land's End
135		The pier, St Ives
136		Low tide, St Ives
137		Boat at St Ives
138		The lighthouse, St Ives
139	WD	Portreath
140		Padstow Bay
141		Rock
142		Padstow Harbour
143		Boat at Padstow

144		Port Isaac
145		Tintagel Castle
146		Nr Tintagel Castle
147	WD	Boscastle
148	WD	Hartland Quay
149		The pier, Clovelly
150		Bideford
151		Barnstaple
152	WD	Clovelly
153		Clovelly
154	WD	Lynmouth
155		Boats at Clovelly
156	WD	Ilfracombe from Hillsborough
157	WD	Lantern Hill, Ilfracombe
158		On the coast near Ilfracombe
159		Low tide, Ilfracombe
160	WD	Near Combe Martin
161		The Rhenish Tower, Lynmouth
162	WD	Briton Ferry
163		Oil refinery, nr Port Talbot
164	WD	The Mumbles lighthouse
165	WD	Worms Head
166	WD	Tenby
167		Tenby Castle and harbour
168	WD	Solva
169	WD	Goodwick Pier, Fishguard
170		Old Fishguard
171		Parrog
172		Church ruins near Newport
173		Boats on the river Teifi nr Cardigan
174		Aberystwyth
175		Aberystwyth – evening
176	WD	View near Aberystwyth
177	WD	Barmouth
178	WD	Caernarfon
179		Menai Bridge
180		Beaumaris
181	WD	Beaumaris
182	WD	Red Wharf Bay
183	WD	Black Marble Quarry
184	WD	Puffin Island
185	WD	Amlwch
186	WD	Holyhead
187	WD	South Stack lighthouse
188	WD	Lady Penrhyn's bath
189		Boats in the harbour, Penrhyn
190	WD	Penmaenmawr
191		Sterns at Conwy
192	WD	Conwy
193	WD	Lighthouse on the Point of Ayr
194	WD	Seacombe ferry, Liverpool
195	WD	Liverpool
196		The Isle of Man ferry, Liverpool
197		Liverpool – dawn
198		Liverpool – under a grey sky
199		Liverpool – the ferry
200	WD	Old Heysham
201	WD	Lancaster
202		Storm over Lancaster
203	WD	Castle Head
204		Piel Castle
205	WD	Piel Castle
206		Fishing boat, Maryport
207	WD	Maryport
208		Old tug, Maryport
209		The harbour, Maryport
210	WD	Whitehaven
211	WD	Caerlaverock Castle
212	WD	Kirkcudbright
213	WD	Cardoness Castle
214	WD	Wigtown
215	WD	Dunskey Castle
216	WD	Mull of Galloway
217	WD	Portpatrick
218	WD	Ailsa Craig from Ballantrae
219	WD	Culzean Castle
220		Culzean Castle – dawn
221	WD	Distant view of Ayr
222		Ailsa Craig from Turnberry
223		Lighthouse, Turnberry
224		Largs
225		Largs – dawn

226		Gare Loch from Gourock
227		Gourock
228	WD	Near Dumbarton
229		Dumbarton
230		Dawn from the Isle of Arran
231		Dawn from the Isle of Arran
232	WD	Lochranza
233		Lochranza
234		Langdale Pikes
235		Devil's Bridge, Kirkby Lonsdale
236		Ruskin's view, Kirkby Lonsdale
237		Hawkshead
238		Kentmere
239		Eskdale from the coast
240		Lake Coniston from Brantwood
241		Lake Coniston – morning
242		Devil's Bridge, Kirkby Lonsdale
243		Langdale Pikes – evening
244		Holy Island, Isle of Arran
245		Old barn, Lochranza
246		Clyde puffer
247		Coniston from nr Brantwood
248	WD	Inveraray Castle
249		Inveraray Castle
250		Inveraray
251		Loch Fyne
252		Inveraray – afternoon
253	WD	Duntrune Castle
254	WD	Dunstaffnage Castle
255		M.V.Pharos
256	WD	Dunollie Castle
257		S.T.S Lord Nelson
258		Oban Harbour
260		Duart Castle
251a		M.V.Pharos
252a	WD	Loch na Keal
253a	WD	Aros Castle
254a	WD	Gribune Head
255a	WD	Aros Bridge
256a		Tobermory, near the ferry
257a	WD	Tobermory
258a		Boats at Tobermory
259a		Isle of Mull from Ardnamurchan
260a		Old boat near Salen
261		The Sound of Mull
262	WD	Ardnamurchan Point
263	WD	Mingary Castle
264		The cathedral, Iona
265	WD	The cathedral at Iona
266	WD	View of Iona from the north-east
267		Iona from the Staffa ferry (1)
268		Iona cathedral – evening
269		Iona from the Staffa ferry (2)
270		A corner of Iona
271		Iona cathedral
272	WD	Staffa from the south-west (1)
273		Staffa from the south-west (2)
274		Staffa from near Fingal's Cave
275	WD	Fingal's Cave
276	WD	The Cuillins
277		The Cuillins – sunset
278		Boats at Uig
279	WD	Loch Scavaig
280	WD	Old Man of Storr
281	WD	Duntulm Castle
282	WD	Isleornsay
283		Dunvegan Castle
284	WD	Dunvegan Castle
285	WD	Eilean Donan Castle
286		Eilean Donan Castle
287		Eilean Donan Castle from the north
288	WD	Loch Duich
289	WD	Glencoe
290		Plockton
291	WD	Portree
292	WD	An Sgurr, Eigg
293	WD	Lighthouse in Scalpay
294		Boats at Rodel pier
295		Rodel church
296	WD	Rodel, South Howis
297		Wreck on Scalpay

298	WD	Stornoway
299		Boats on Scalpay
300	WD	Remains of Temple at Galton
301	WD	Druidical stone at Barvas
302	WD	Brochel Castle, Raasay
303	WD	Looking westward from Raasay
304		Shieldaig
305		Waterfall near Loch Maree
306	WD	Gairloch Head
307		Loch Torridon
308	WD	Charlestown, nr Gairloch
309		Diabaig
310		Loch Maree
311	WD	Suilven, from Lochinver
312	WD	Near Unapool and Kylesku
313	WD	Lochinver
314		Loch Broom
315	WD	Pier at Tanera, Summer Isles
316		Ullapool
317		Mountains and lake
318		Quinag – dawn
319		Quinag
320		Near Lochinver
321		Boats at Achiltibuie
322	WD	Rispond, Durness
323	WD	Entrance to Smoo Cave
324	WD	Whiten Head, Loch Eriboll
325		Boat at Rispond
326		Two boats at Rispond
327		Two boats at the pier, Rispond
328	WD	Strathnaver
329	WD	Bay of Tongue
330		Farm near Tongue
331	WD	The Clett Rock, Holborn Head
332		Lighthouse, Scrabster
333	WD	Distant view of Thurso
334	WD	Stromness
335	WD	The Ring of Brogar
336		Low tide, Sanday
337	WD	Kirkwall from the bay
338	WD	Remains of the Earl's' Palace, Kirkwall
339	WD	The cathedral, Kirkwall S.E. view
340		Kettletoft
341	WD	Lighthouse, Start Point, Isle of Sanday
342	WD	The Old Man of Hoy
343	WD	The cathedral, Kirkwall N.W. view
344		Low tide, Sanday
345		Distant view of lighthouse, Sanday
346		Ruin on Sanday
347	WD	Tower of the Bishop's Palace, Kirkwall
348		Letterewe Forest, Loch Maree
349		A burn near Loch Torridon
350	WD	Thurso Castle
351	WD	Castlehill, near Thurso
352	WD	Scarfskerry
353	WD	The Castle of Mey
354	WD	John o'Groats
355		Boats at Castlehill
356	WD	Duncansby Stacks
357	WD	Keiss Castle
358		Duncansby Stacks
359	WD	Ackergill Tower
360		Distant view of Ackergill Tower
361	WD	Castles Sinclair and Girnigoe
362	WD	Old Wick Castle
363	WD	Wick
364	WD	Hempriggs Stack
365		Boats in Wick harbour
366		Fishing boat up for repairs
367	WD	Scene at Hempriggs
368	WD	Helmsdale
369		The harbour, Latheronwheel
370	WD	Berriedale Castle
371		Helmsdale valley
372		The harbour, Lybster
373	WD	Berriedale
374	WD	Dunbeath Castle
375		Dunbeath castle from the beach
376		Dunbeath harbour
377		The harbour, Brora

378 WD Dunrobin Castle from the N.E.
379 WD Dunrobin Castle – evening
380 Coastal path nr Dunrobin Castle
381 WD Dornoch
382 WD Cromarty
383 WD Pier at Fortrose
384 WD Inverness
385 Inverness – evening
386 WD Nelson's Tower, Forres
387 Findhorn
388 Spynie Palace
389 Cullen
390 Sunset, Lossiemouth
391 WD Coxton Tower, near Elgin
392 Findochty
393 Sandend
394 WD Findlater Castle
395 Portsoy
396 Boats at Portsoy
397 WD Banff
398 WD Duff House, Banff
399 Boats at Macduff
400 Gardenstown
401 Crovie
402 Pennan
403 WD Kinnaird Head, Fraserburgh
404 Fogbound, Fraserburgh
404a WD Fraserburgh
404b WD Peterhead
404c WD Slains Castle
405 Port Erroll
405a WD Bridge of Don, Old Aberdeen
406 WD Aberdeen

407 Stonehaven
408 WD Dunnottar Castle
409 Dunnottar Castle – evening
410 WD Inverbervie Bridge
411 WD Montrose
412 Edzell Castle
413 Bridge of Dun
414 Arbroath

415 WD Broughty Castle
416 WD St Andrews
417 St Andrews
418 St Andrews Castle
419 Anstruther Wester
420 Anstruther Wester – evening
421 Pittenweem
422 WD Edinburgh from the Castle
423 WD Edinburgh from Calton Hill
424 Calton Hill – evening
425 WD Leith
426 Oil rig in Leith docks
427 Tantallon Castle
428 WD Tantallon Castle
429 WD Bass Rock
430 Bass Rock
431 WD Berwick-upon-Tweed
432 Holy Island
433 Holy Island
434 WD Lindisfarne
435 WD Bamburgh Castle
436 Bamburgh Castle
437 Bamburgh Castle
438 Dunstanburgh Castle
439 Dunstanburgh Castle
440 Warkworth Castle
441 Warkworth Bridge
442 WD Tynemouth
443 WD North Shields
444 Staithes
445 Boats at Low tide, Staithes
446 WD Whitby
447 WD Whitby Abbey
448 Morning mist, Whitby
449 WD Wemyss Castle
450 WD Wemyss Castle
451 WD Dunbar
452 Dawn at Broughty Ferry

453 Robin Hood's Bay
454 WD Scarborough
455 WD Lighthouse on Flamborough Head

456 WD Boston
457 The Customs House, King's Lynn
458 A corner of King's Lynn
459 Thornham
460 Burnham Overy Staithe
461 Wells-next-the- Sea
462 Low tide, Wells-next-the Sea
463 On the marshes near Wells-next-the-Sea
464 Morston Quay
465 Blakeney from Morston Quay
466 Old hulk at Blakeney
467 Dawn over the marshes, Blakeney
468 Sunset, Blakeney
469 Cley-next-the Sea – evening
470 Distant view of Cley-next-the Sea
471 The windmill, Cley-next-the-Sea
472 The beach at East Runton
473 Cromer
474 Horsey Mill
475 WD Great Yarmouth
476 Gorleston-on-Sea
477 WD Lowestoft
478 The lighthouse, Southwold
479 WD Southwold
480 Walberswick
481 Fishing boats at Dunwich
482 Evening, Dunwich
483 On the beach, Aldeburgh
484 Boats at Aldeburgh
485 Evening, Aldeburgh
486 Slaughden
487 On the Alde at Snape
488 Iken
489 Evening, Orford
490 The boatyard, Orford
491 WD Orford Ness
492 Boats at Woodbridge
493 Old Felixstowe
494 On the hard, Pin Mill
495 Old barges at Pin Mill
496 Hulks at Pin Mill

497 Harwich from Shotley
498 WD Harwich
499 WD Mistley
500 Low tide, Mistley
501 Walton Backwaters
502 Brightlingsea
503 Wivenhoe
504 Tollesbury
505 Heybridge Basin
506 Maldon church
507 Maldon, low tide
508 Maldon, evening
509 Burnham-on-Crouch
510 Low tide, Leigh-on-Sea
511 WD Southend-on-Sea

OTHER VIEWS BY WILLIAM DANIELL ON HIS VOYAGE ROUND GREAT BRITAIN

TITLES ARE AS INSCRIBED ON HIS AQUATINTS

1	Ovington, near Brighton.	Not visited
2	Mr Nash's House, Isle of Wight.	Demolished and now a housing estate
3	View of the Needles and Hurst Castle	Castle seen but not depicted
4	Torbay	Visited but not depicted
5	Torbay	Visited but not depicted
6	Catwater, Plymouth from the Citadel	Military establishment – access refused
7	Mt Edgecumbe from the Citadel, Plymouth	Military establishment – access refused
8	2nd view of Mevagissy	Visited but not depicted
9	Near Mullyan Cove	Not visited
10	2nd view of St Michael's Mount	Sketched but not published
11	The Long-ships Lighthouse	Not visited
12	St Donats	Visited but totally obscured by trees
13	The Eligug-stack	Military establishment – access refused
14	View of the entrance to Fishguard	Sketched but not published
15	Part of the South Stack, Holyhead	Not visited
16	The Rope Bridge, near South Stack	Not visited
17	View near Hoyle-lake	Visited but not depicted
18	The Towns-end Mill, Liverpool	Site could not be ascertained
19	Distant view of Whitbarrow Scar	Viewpoint could not be found
20	Harrington, near Whitehaven	Visited but not depicted
21	Near Carsleith	Site could not be ascertained
22	Cree-town	Site could not be ascertained
23	Pier at Ardrossan	Visited but not depicted
24	The Isle of Arran taken nr Ardrossan	Visited but not depicted
25	Ardgowan	Visited but not depicted
26	Greenock	Sketched but not published

27 Mount Stuart, Isle of Bute	Visited but closed
28 Loch Swene	Visited but not depicted
29 Rassella, near Kilmartin	Not visited
30 On the Isle of Jura	Not visited
31 Clam Shell Cave, Staffa.	Visited but not depicted
32 Exterior of Fingal's Cave	Visited but not depicted
33 Entrance to Fingal's Cave	Visited but not depicted
34 Staffa, near Fingal's Cave	Sketched but not published
35 The Cormorants Cave, Staffa	Not visited
36 View from the Island of Staffa	Visited but not depicted
37 The Island of Staffa from the East	Visited but not depicted
38 View of Ben-more from nr Ulva House	Not visited
39 Remains of the Chapel on Inch Kenneth	Not visited
40 Part of the Isle of Rum	Not visited
41 Armidal, Isle of Skye	Not visited
42 Balmacarro House, Loch-alsh	Visited but not depicted
43 Ilan-dreoch, Glenbeg	Not visited
44 The bay of Barrisdale in Loch Hourne	Not visited
45 Loch Hourne Head	Not visited
46 Near Kylakin, Skye	Sketched but not published
47 Liveras, near Broadford, Skye	Visited but not depicted
48 2nd view of Dunvegan Castle	Visited but not depicted
49 Little Brieshmeal, Near Talisker	Not visited
50 Loch Coruisq, near Loch Scavig	Not visited
51 Northern face of Shiant Isles	Not visited
52 Near View of one of the Shiant Isles	Not visited
53 Creen-stone Rock, Loch Broom	Not visited
54 Near the Berry-head, Hoy, Orkney	Not visited
55 The Snook, Hoy, Orkney	Not visited
56 The Cathedral of St Magnus, Kirkwall	Visited but not depicted
57 Forse Castle	Visited but not depicted
58 Bonar Bridge	Visited but not depicted
59 Nairn	Visited but not depicted
60 Obelisk at Forres	Visited but not depicted
61 Brugh-head	Visited but not depicted
62 Boyne Castle	Visited but not depicted

63 Dundee Visited but not depicted
64 Edinburgh with the North Bridge and Castle Visited but not depicted
65 Sunderland Pier Visited but not depicted

66 Kingston-upon-Hull Visited but not depicted

INDEX

Aberdeen 43
Ackergill Tower 17

Bamburgh Castle 59
Banff 37
Bass Rock 55
Berriedale 24
Berriedale Castle 25
Berwick-upon-Tweed 57
Boston 66
Bridge of Don 42
Broughty Castle 47

Castlehill, nr Thurso 11
Castle of Mey, The 13
Castles Sinclair & Girnigoe 18
Coxton Tower 34
Cromarty 30

Dornoch 29
Duff House, Banff 36
Dunbar 56
Dunbeath Castle 23
Duncansby Stacks 15
Dunnottar Castle 44
Dunrobin Castle 27
Dunrobin Castle from N.E. 28

Edinburgh from Calton
 Hill 51
Edinburgh from the Castle 52

Findlater Castle 35

Flamborough Head 65
Forres, Nelson's Column 33
Fortrose 31
Fraserburgh 39

Gorleston-on-Sea
 (Great Yarmouth) 67

Harwich 72
Helmsdale 26
Hempriggs Stack 21
Hempriggs, scene at 22

Inverbervie Bridge 45
Inverness 32

John o'Groats 14

Keiss Castle 16
Kinnaird Head 38
Kirkwall from the bay 5
Kirkwall, N.W. view of
 cathedral 3
Kirkwall, S.E. view of
 cathedral 4
Kirkwall, Bishop's Palace 6
Kirkwall, Earl's Palace 7

Leith 53
Lindisfarne 58
Lowestoft 68

Mistley 71

Montrose 46

North Shields 61

Old Man of Hoy 9
Orford Ness 70

Peterhead 40

Ring of Brogar 2

St Andrews 48
Scarborough 64
Scarfskerry 12
Slaines Castle 41
Southend-on-Sea 73
Southwold 69
Start Point, Isle of Sanday 8
Stromness 1

Tantallon Castle 54
Thurso Castle 10
Tynemouth 60

Wemyss Castle 50
Wemyss, view towards
 Edinburgh 49
Whitby from the north 62
Whitby Abbey 63
Wick 19

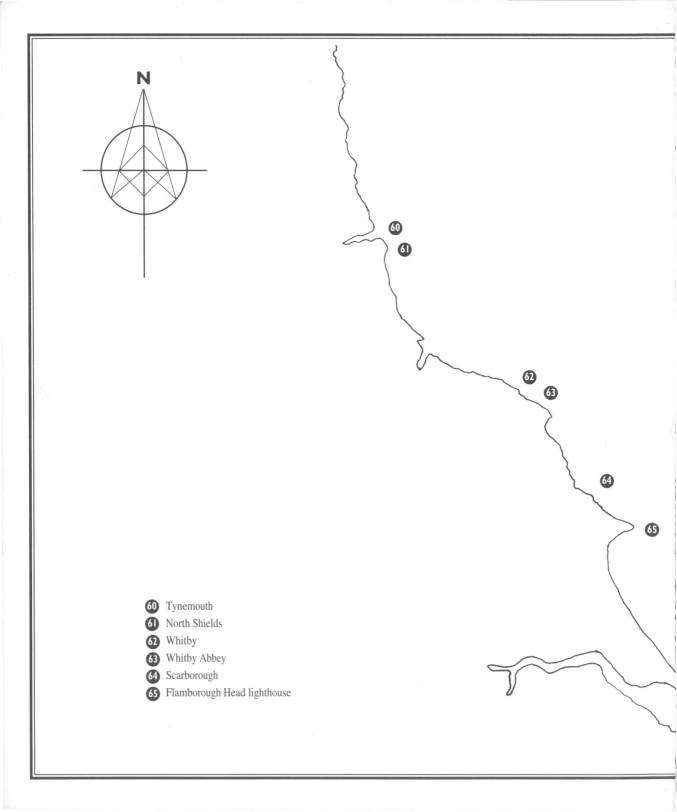

N

- **60** Tynemouth
- **61** North Shields
- **62** Whitby
- **63** Whitby Abbey
- **64** Scarborough
- **65** Flamborough Head lighthouse